Cubanthropy

Cubanthropy

Between the Cold War's Socialist
Promise and a Capitalist Future

IVÁN DE LA NUEZ

Translated by
ELLEN JONES

SEVEN STORIES PRESS
NEW YORK • OAKLAND

Seven Stories Press
140 Watts Street
New York, NY 10013
sevenstories.com

College professors and high school and middle school teachers may order free examination copies of Seven Stories Press titles. Visit https://www.sevenstories.com/pg/resources-academics or email academic@sevenstories.com.

Library of Congress Cataloging-in-Publication Data

Names: Nuez, Iván de la, author. | Jones, Ellen, 1989- translator.
Title: Cubanthropy : between the Cold War's socialist promise and a
 capitalist future / Iván De La Nuez ; translated by Ellen Jones.
Other titles: Cubantropía. English | Between the Cold War's socialist
 promise and a capitalist future
Description: Oakland : Seven Stories Press, [2023] | Includes
 bibliographical references.
Identifiers: LCCN 2022053230 | ISBN 9781644213247 (paperback) | ISBN
 9781644213254 (electronic)
Subjects: LCSH: Politics and culture--Cuba.
Classification: LCC F1788 .N74313 | DDC 972.91--dc23/eng/20230810
LC record available at https://lccn.loc.gov/2022053230

Printed in the USA.

9 8 7 6 5 4 3 2 1

CONTENTS

Nobody knows what the past will bring.
—CUBAN PROVERB

The future is already here—
it's just not evenly distributed.
—WILLIAM GIBSON

IRRUPTION:
Thinking Between Two Futures

This book was written between two futures.

The first was taken for granted as part of the Cold War's socialist promise.

The second—a capitalist future—emerged once that war was dead and buried.

I know...

In a world that screams its lack of future from the rooftops, moving between two of them is an untold luxury. But this is a "Cuban" book, so exaggeration was always going to form part of its architecture.

If you want to understand Cuba, you've come to the right place.

Chronologically speaking, these essays span four decades and run from the height of the US-Cuba conflict to its fleeting détente (we could also say there's a thread running from Reagan to Trump, from Ronald to Donald, in a form of eternal return).

Let's leave it at that: between the devil and the deep blue sea.

Geographically speaking, they lurch back and forth between the Berlin Wall and the Havana Malecón. Along the way, they collide with almost every aspect of global culture: dictatorship and democracy, postcolonialism and the digital era, center and periphery, memory and lobotomy, plantation and tourism, geography and history, diaspora and nation, market and ideology, hedonism and commitment, son cubano and Big Data, utopia and Guantánamo, soccer and baseball, Prospero and Caliban, Europe and the United States, Nietzsche and reggaeton.

Anyway, the whole book is laid out on the contents page.

From there, it's easy to see that these are essays about themes rather than authors. Perhaps it's worth emphasizing that they are united by their resistance to acting as tour guides to the "Cuban situation."

Cuba is not explained to the world in these pages, but rather the other way around: Cuba is *used* as a scale broad enough to take in that world and its repertoire of conflicts. Critique of Cuban culture is important. But so is a critique of the ways it has been depicted beyond its borders.

This book begins with the omnipresence of Fidel Castro and ends just after his death.

Without downplaying the importance of that double whammy, it's worth clarifying that in these pages the word "Castro" is less important than the word "art." Or the word "life" or "people" or "travel."

That relative importance is, above all, a stance. And *cuban-thropy*, rather than a doctrine, is more like an energy. A coinage that's useful for defining the growing whirlwind between anthropology and entropy, the street and the library, the nightclub and the museum, the island and the world.

Cubanthropy is a book about the cultural effects of the policies that have tried to constrain or liberate Cuba over recent decades. It can also be read as an intellectual biography or, at a pinch, as a map of the cultural production of the New Man, of Cubans born since the Revolution; the collective Frankenstein imagined by Che Guevara, the first subjects not to spread capitalist contamination.

If, as Robert Louis Stevenson said, sooner or later everyone sits down to a banquet of consequences, consider this book my Cuban bacchanal.

Even the most uprooted of humans comes to wonder—like that president who was shot dead—what they can do for their country. Some have responded by giving their lives, or by taking others'. I know intellectuals who have called for blood.

As for me: I give these essays.

BETWEEN THE DEVIL
AND THE DEEP BLUE SEA
1990–1991

I

It starts with the suspension of the Cold War, and Cubans at the center of the conflict.

It starts with the ageing New Left invoking the sixties in order to demonstrate the rightness of Cuba choosing to go it alone outside the Soviet Bloc, and with the sprightly New Right *rejecting* the sixties in order to emphasize their victory over communism.

Between the devil and the deep blue sea ...

In 1989, the old revolutionary guard looks back to the sixties to recover Cuba's glory days.

In 1989, the new conservative guard looks back to the sixties to bad-mouth North American decadence.

II

It starts with Reagan and Bush Senior proclaiming their victory over communism and with the United States shaken up by a sense of catharsis that had to be contained as quickly as possible.

Daniel Bell believed that modern excesses had inverted the famous eighteenth-century motto: *private vices, public virtues.* This "most brilliant of conservatives," according to Habermas, was persuaded that in the United States, thanks to the sixties, vices had become public and virtues—hampered by the prevailing way of life—had become private.

On the basis of this conviction, not just Bell but also Kramer, Podhoretz, Kirkpatrick, Novak, and Showell, along with other neoconservative think tanks, managed to pull together the cultural strategy of neoliberalism. For them, if social modesty had led capitalism to hide behind the skirts of the Welfare State, now the time had come for it to show its face: to insist, with no beating about the bush, that the problem wasn't that the system had failed but rather that it had been an "overwhelming success." And if the sixties had brought the national agenda into question, it was now time to banish all doubt once and for all. To which end, the New Right were kind enough to reconstruct the genealogy of the conservative tradition, rescuing the lost aura of the elite, dusting off Adam Smith, and harking back to the golden years of Philadelphia.

In case that wasn't enough ammunition, there was always Reagan to confirm that leadership was indispensable; Milton Friedman to give credence to the idea that the market was invincible, and Bell himself to argue that a return of the protestant ethic was inevitable.

All agreed on the harmful impact of hedonism on capitalist competition. And between them they tilled the authoritarian soil of the "neoconservative revolution" that commended Jesse Helms and his Moral Majority against internal threats as much as Chuck Norris and his lethal minority against external enemies.

The neoconservatives longed for an imperial culture gone astray, and the communist hecatomb served them their lost grandeur on a silver platter once again. It was a return that would allow them, meanwhile, to adapt the old Monroe Doctrine of 1823—which prohibited the intervention of European powers in the internal affairs of countries in the American hemisphere—to the brand-new global era.

This time, not only the American continent but the whole world would be "for Americans."

III

Cubans have danced to this music since 1959. They have been in the very nucleus—rather than on the periphery—of a Cold War constant that has condemned them to live in an anti-project. In such a way that, once the Berlin Wall came down, the island elite also felt obliged to replenish their symbolic arsenal in order to survive the Friendly Empire and stand alone against the Enemy Empire. And to achieve this, the best thing was to reinforce the connection between National Identity and Anti-Imperialism. Or to resuscitate, in the post-Soviet world, the initial halo of a revolution that was once young, original, and also—it's worth reminding the colonial souls among us—Western.

This resolve was anchored in an irrefutable truth: Cuba's short march through history has almost always been out of step. Although the island achieved its independence at the end of the nineteenth century, several decades after most other Spanish colonies, by the middle of the twentieth century it mounted the hemisphere's first socialist revolution. And although in 1989 the Soviet Empire collapsed along with its galaxy of "sibling countries," nine thousand kilometers away Cuba was managing to survive as a communist country outside the defeated Bloc.

What was the explanation for the persistence of Cuba's regime, alongside those of China, North Korea, and Vietnam? It was precisely that exceptional story, which contained enough signs that the country had never been just another star in the Soviet galaxy. In the nineteenth century, Cuban thinkers were busy insisting that Cuba wasn't Cipango or Albion or Sicily. Now, heading into the twenty-first century, it was time to make clear it wasn't Bulgaria or Romania or Albania either.

Just in case, Fidel Castro had already erected his tent on the outskirts of the perestroika. He called it the Process of Rectifying

Errors and Negative Tendencies, and it was via this process that he redoubled the nationalization of the economy, revived a Che Guevara half-buried in the pro-Soviet era, and, now involved in processes of indoctrination, replaced the Russian language with English and replaced scientific communism with subjects that reinforced the authenticity of the Cuban model. Speaking of which, even certain magazines previously considered sympathetic to socialism (*Sputnik* or *Novedades de Moscú*, for instance) were declared subversive.

In Cuba—going it alone, disconnected from a world that had survived the fall of communism—the ecstasy of exceptionality reached its peak. For this reason, nationalist intellectuals came to the fore once more; whether they were Catholics—Cintio Vitier—or followers of Che Guevara—Fernando Martínez Heredia and other *Pensamiento Crítico* magazine editors and contributors—they had been suspicious during the Stalinist era. A few now dedicated themselves to the task of authenticating a Cuban tradition based on an amalgamation of the concepts of Identity, Homeland, and Revolution. It was all an exercise in cultural fortification against the global post-communist, multipolar world rising up threateningly across the sea.

With Soviet help diminishing, China not yet having reached its apogee, the conflict with the United States still ongoing (including Exile, Embargo, and the Guantánamo naval base), and the Bolivarian States yet to be born, in Cuba the nineties highlighted an exclusive—and exclusionary—pathos that rejected any knowledge opposed to the official line.

There was also, in theory, support for those in power to retain it under different circumstances. Because at the end of the day, we're talking about power, not philosophy. To the extent that, during those years, I explained the national discourse of the Cuban Revolution by resorting to the figure of a piston: any space

that expands outward ends up getting compressed inward again. And the demands Cuba was making around the world for the right to diversity weren't often met at a national level.

According to the official logic at the time, compared to the rest of the world, what made Cuba different was that it was *revolutionary*. That said, any kind of difference arising internally was considered *counterrevolutionary*. Depending on the case and the particular charges brought, difference might also be considered globalist, pro-imperialist, postmodern, neoconservative, or diversionary (I know of one that ticked all those boxes at the same time).

Exacerbating everything was the ongoing confrontation with the United States. Without that tension it's impossible to understand Cuba's symbolic dimensions: the image of the small state against the Great Empire. This conflict, more than its internal political model, is the fire that has fed the Cuban singularity, even in the most critical and extraordinary moments of its discourse. It is the principal attraction ensuring the continuity of the Revolution's seminal imaginary, even long after it was institutionalized as a communist state.

If internal history had told us we were exceptional by *tradition*, the United States made us exceptional by *obligation*. If in Cuba there was only ever one election candidate, or the Beatles were banned, or men couldn't have long hair, or post-structuralism was censored, or the government never changed, or we had strange allies, it was for one very clear reason: the powerful enemy opposite us.

IV

Can anything be achieved between the hard, irreconcilable lines drawn on either side of the Gulf Stream? Every essay in this book examines that territory. That area that will never appear in the annals of Great Causes, but rather in the almost domestic sphere

of small consequences. In the spaces where culture modestly achieves its goal of bringing official powers—whichever form they might take—under suspicion.

In that vein, there was the challenge posed by the new culture led by the sons of the Revolution, by that New Man outlined by El Che, who, as the Cold War intensified, decided to try out his very own private glasnost.

There were a number of different projects operating in Cuba in 1990 that revealed this surprising irruption. And to be sure, the macro-political disagreement between the governments of Cuba and the United States didn't help much. Just as would happen years later with artists from the Axis of Evil countries delimited by George W. Bush, in the era of Bush Senior one was always at risk of being crushed between two dogmatisms.

Even so, it fell to those new intellectuals to reinscribe the country into Western culture after years of the Soviet model, apparent or covert, a process facilitated by the fact that communism in Eastern Europe was to pass away.

The problem is that the Cuban government was not prepared for this ideological, aesthetic, and political avalanche that strained the foundations of its cultural policy: "Within the Revolution, everything; against the Revolution, nothing."

Despite it all, the arrival on the scene of the baby boomer generation triggered by that same Revolution was inevitable. Osvaldo Sánchez called them "the children of Utopia"—the only ones who had never known anything but the socialist experiment. They wouldn't be, as Alejo Carpentier predicted of his generation in the thirties, "the classics of a new world," but they were the perfect symbol of the Cuban model's advancing years.

And the thing is, despite the US embargo and the collapse of the Communist Bloc—the usual explanations for the island's catastrophes—it's the rupture caused by this movement that

allows us to decipher the irrevocable meaning of the subsequent Cuban crisis. In the fact that the children of socialism were to find, one day, that the Revolution had turned into the State, that the capital-*E* Enemy was also allowing (as in "The Boy Who Cried Wolf") an authoritarian hierarchy to crush even the slightest attempt to change from within, that the ideology had acquired the status of a fundamental (and fundamentalist) commodity of the system, and that every Cuban family was uprooted: with a doctor in Moscow (not Zhivago, mind you), a martyr in Africa, a lost relative in Miami, and—the most perfect metaphor for their existence—a refugee adrift in the Gulf Stream.

The most notable change, and the most feared, was in the visual arts, which were used to impose trends and establish leadership, all with a shrewd eye for communicating cultural messages. So, for instance, when the street art group Arte Calle flooded the city with graffiti, announcing "the concert's happening," they weren't betting on the spectacle actually happening, but rather on the spectacle of it *not* happening. Their message relied not on their followers' complacency, but rather on their insatiability.

In contrast to the catharsis stopped short by the neoconservatives with which this chapter began, when the Berlin Wall came down, we found no dissolving of culture into politics in Cuba (a common complaint from the new censors in the United States). On the contrary, it was the practical and rhetorical uses of politics that colonized the cultural movement, and indeed other areas of society. Whether down the transcendental road of the sixties, or via the laudatory reproduction of the Soviet model applied in the seventies, what is clear is that the following years saw culture harassed by the same trans-political universe.

Would we ever be able to effectively dismantle either world?

This was, in good part, the question that emerging intellectuals and artists were asking at the end of the twentieth century

in Cuba: whether Cuban culture was to arrive, by means of its institutions, at a democratic synthesis that assumed plurality, or whether each of us was to set out on our own expedition toward definitive dissolution.

Perhaps it was too soon to abandon socialism, but too late to return to the Revolution.

ONE, TWO, THREE, ENSAYANDO . . .

2010

"Nonfiction" is the Anglo-Saxon word for anything that can't be defined as narrative fiction and tends to resemble essay writing or even theory. I have always been irritated by this negative definition, with its crushing prefatory "non-." Nonfiction, and especially the academic practices to which it gives rise, contains some of the admonitory vanity of a person in possession of The Truth (The Whole Truth and Nothing but the Truth).

From my exceptionally partial perspective, nonfiction is both status and territory: a delimiting of the field on campus. A floodgate holding back the waters and, at the same time, a market stall where the publishing industry, academia, and cultural supplements meet.

Nonfiction is the wall against which all readers of Montaigne must collide from time to time.

It's not a question of playing the hero. Nor of asking to be taken in where we are not welcome, nor even, let's be honest, of qualifying for a medal. At the end of the day, stale terminology isn't even the most difficult obstacle facing the essay. Although I have often found it irritating, for me it was neither the first nor the most painful knock I took in my early career.

When I look back, I see myself at the height of this conflict. On the beach where I grew up, some twenty kilometers from Havana. It was called—is still called (it's still there, although not entirely in one piece)—Baracoa. It shares its name with the first Spanish settlement, founded by Diego Velázquez, at the other end of the island, and the two ought not to be confused.

"My" Baracoa, among other vicissitudes of its infra-history, once had an orchestra: Los Hermanos Silva. The band was largely made up of fishermen and textile workers, and they had their heyday, such as it was, in the forties and fifties.

Los Hermanos Silva had two distinguishing characteristics: they played drunk, and they didn't know when to stop (there was always one drum roll too many that obliged them to swing back into the chorus again, making them experts in "extended versions"). But Los Hermanos Silva kept people entertained and, above all, entertained themselves with their bizarre events. You could always tell when the slide into alcoholic stupor had become inevitable, both by the radicalization of their harmonic chaos and because it was at this point that they invariably launched an attack on the salsa number "Componte canallón" (Pull yourself together, you wretch).

Eventually, death and other necessities led the orchestra to disband, becoming nothing more than a memory, old men reminiscing about the good old days (when there were parties with "real" dancers: local stars like Yiyo Gómez as well as a global giant like Benny Moré). Sometimes, the survivors would improvise a trio or a quartet in an entranceway (these remnants were all I ever managed to see), but the sound they made was so bizarre that only their dipsomaniacal hit was even vaguely recognizable.

Among them there was a sullen, unattractive man named Linao. This man never assimilated to life after 1959—the Revolution, which changed practically everything, never managed to change him. His refusal to adapt—a snide form of protest—notably included his attire. All his clothes, right down to his underwear, were from "before." I can still see him, dressed all in white: pencil moustache, wide-leg batahola trousers, excess hair oil, boxer shorts visible, and under his starched white shirt a gold-trimmed vest known as a "guapita." The outfit was com-

pleted with an outsized gold chain bearing an Our Lady of Charity medallion around his neck. (Diddy Combs could use Linao's wardrobe to start a hip-hop fashion line that would sweep the floor with "Been Around the World.") One day, around the time I was leaving adolescence behind, it occurred to me when I was with Linao to use the magic word: "ensayo." Rehearsal, essay, attempt.

Basically, I asked him where the orchestra used to rehearse, and when, and how they put together their repertoire. In response to these innocent questions, the man reacted with such violence that he threatened my physical integrity. Once he'd been placated, he finally ground out the reason for his rage: "Los Hermanos Silva orchestra never rehearsed—never essayed—ever." I still hadn't written a single essay, but I was already learning that my vocation could cause offense.

Years later, there were other, more serious disagreements. I won't dwell on these conflicts now, only remark that, thanks to them, I learned a second lesson: in addition to being offensive, the essay could be "deviant," according to the respectable norms upheld by the holy guardians of the fundamentals of Stalinism. So I took my essays elsewhere, although my "Cuban" problems with the curvature of the essay didn't end with orthodox islanders. I still got my dose of tropical Calvinism "outside." While texts could be "deviant" Over There, turns out that Right Here they could be "crooked."

Third lesson learned: according to essayistic patriotism, for an essay to qualify as Cuban, no matter the ideology that animates it, it must, above all, be "straight." (The intellectual version of a stake in the ground.) This is because Cubans think the essay has ideological problems. In truth, it's not that the essay *has* an ideological problem, it's that it *is* an ideological problem, the whole thing.

These were the kinds of tropical questions I was mulling over when nonfiction came—or rather, tried to come—into my life . . .

For me, there will always be that pathetic pride at not having succumbed to nonfiction.

There will always be Montaigne.

And the consolation that the inventor of the modern essay himself doesn't easily fit that classification: How can we remove from the realms of fiction a man whose essays are built by linking stories together? Montaigne, even Montaigne, would have to polish some of his best lines before being welcomed into the Nonfiction Club. This one, for example: to write essays is to paint oneself.

I should perhaps warn that, being an omnivorous reader, I tend to consume rather a lot of books understood to be nonfiction. There was a time when I had no choice about it, because I reviewed essays for the cultural supplement of a newspaper. Perhaps because I reached a saturation point, my consumption of this kind of text has waned somewhat. This hasn't rid me entirely of curiosity about them (just recently my friend Jorge Brioso took it upon himself to try and get me into a new trend of writing against "essayism" in US academia).

But I still think of the essay in its theatrical form, as a rehearsal, a preliminary and imperfect approximation of a reality that is not yet fully constituted. (The real show hasn't even begun.)

Athletes tend to remember excitedly what they used to achieve in a training session. The Beatles, being the Beatles, committed themselves to recording all their rehearsals.

So essay writing isn't even a trade, nor is it a literary genre, exactly. It has a lot of attitude. It takes in the draft, the sketch, the plan. It takes in training on the field and laboratory experiments.

It takes in tuning the piano and sharpening the knife . . .

TOWARD A COMPARATIVE
COUNTERCULTURE
1988–2015

Somewhere in this world there must be a museum with the courage to mount an exhibition of the communist underground scene. A comparative counterculture, able to explore the alternative spaces occupied by the underbelly of a system conjugated in the future tense and lauded by millions as humanity's final destination.

It would be a project capable of linking Eduard Limonov with Reinaldo Arenas. A radical Soviet born in Kharkov and an ebullient Cuban born in Holguín—a kind of tropical Kharkov.

The exhibition would have an obligatory play and recreation area, all jokes included; and another for the rule-breaking strategies that successfully dodged the cultural parameters of the party and of bureaucracy.

Milan Kundera's first novel explores this possibility. It was also the first book that got him into trouble, and it is surely no coincidence that it was titled *The Joke*.

In an exhibition of this kind, there would have to be a section dedicated to Cuban art from the eighties. To that collective performance brought about by the generation of the New Man, the same generation that, according to Che Guevara, was destined to create a culture uncontaminated by the past.

These young Cubans differed from their contemporaries elsewhere in the communist world in certain unique ways, but they also shared points of contact, including the hope of being able to break open the system from within. So when it became official

that the Cuban government wouldn't follow in the footsteps of the perestroika, those artists remained, as Heberto Padilla would say in his famous poem, "fuera del juego" (out of the game).

Not because they were looking for a "political" way out, in the strict—and solemn—sense the word "political" tends to have. But rather because they made it clear that capital-*P* Politics wasn't entirely welcome in their ranks.

Nor was their search based on a longing for a capitalism they had never lived, but rather for a freedom that they had been conquering little by little.

Yet all this is still curious, because between 1980 and 1990 Cuban cultural politics had committed itself to a rather unusual undertaking: the configuration of a Western Art System not governed by the market. Obviously, other communist countries weren't dependent on the market either, but they lacked a Western-style Art System. For their part, Western countries, the inventors of the model, naturally revolved around the central pivot of market relations.

Here it's worth recognizing that, in the eighties, some institutions opted for an opening that led to that paradoxical model of a "social democratic" institutional style—Biennials, Art Centers, project subventions—under the political, ideological, and economic coordinates of actual socialism.

Quite the asymmetry.

Naturally, these institutions had urgent tasks, such as reinstating Cuban culture in the West—something that had been interrupted by the Stalinist political system of the seventies—or patching up the traumatic impact of the Mariel boatlift (1980) with which the decade began. As if that weren't enough, they had to confront the coming of age of artists, born during the demographic boom of the sixties, who had only ever known the Revolution.

This gave those creators—in addition to all the conflicts, which were many—an initial advantage: How could the cultural authorities not accept the discourses and practices of artists they themselves had trained?

At this point, it's worth highlighting the expansion of artistic commissions into other areas of society; the revelation of the lack of information in the official press; the development of an anthropological trend that drew from arte povera and was rooted in Artaud, Grotowski, and Beuys; the emergence of avant-garde manifestos; the evocation of the un-institutionalized years of the Revolution; the sublimation of performance; the search for a collective alternative to overcrowding; the launching of multi-disciplinary projects; the opening up to pagan forms of culture, especially Afro-Cuban religions; the creation of an imaginary city by architects with zero chance of being able to build the actual city; the aforementioned reinsertion of Cuban culture into the West; the connection with the Eastern European underground; the questioning of national symbols and heroes through shocking, problematic display; the use of irony and games; the lack of sexual prejudice; the production of art criticism working against the wizened Marxism of political manuals . . .

All this was at risk in the art being made while communism was collapsing in Eastern Europe and Sandinismo was taking off in Central America, while the New Right was reaching its peak in the United States and the New Left was ageing in Cuba.

In 1989, the collapse of the Communist Empire coincided with the end of this artistic movement. So while the world was ushering in the global era, Cuba began to move toward a survival phase that would come to be known as the Special Period in the Time of Peace.

Perhaps predicting a climax, the sense of an ending, it was then that a group of artists decided to organize a baseball game.

YOUNG ARTISTS TAKE ON BASEBALL. So read the poster announcing the performance. In Cuba, playing baseball is simply called "playing ball." And when someone says, "Let's talk about the ball," what they mean, it's clear to all, is "Let's *not* talk about politics."

That game of baseball, then, was a way of emphasizing that they were done with contemporary politics.

The swan song of Cuban art by the children of the Revolution.

And a dignified gesture from an artistic movement that had wanted to conquer aesthetic contemporaneity where their parents had petrified political contemporaneity—a tribute they paid to themselves.

THE YEAR WE BROUGHT DOWN THE WALL
1989–1999

I

In the spring of 1989—a few months before the Berlin Wall came down—I traveled through Eastern Europe visiting a handful of communist countries that were "siblings," though not for long, of socialist Cuba. That tour—the last one to express a sense of brotherhood among those states—changed both my future and the way I look at the world; it did away with what remained of my ideological innocence and, incidentally, laid the foundations for a couple of books I was to later publish: *La balsa perpetua* (The perpetual raft) and *El mapa de sal* (The salt map).

I had just returned to Cuba from Nicaragua, where the air was thick with the smell of the end of the Sandinista era. So, in a matter of weeks, I went from Managua—where I felt as if I were living in the Cuban Revolution's Latin American past—to those far-off cities embodying the "European" future Cuba still had in store.

Sofia, Moscow, Minsk, Warsaw, Bratislava, Prague . . .

I traveled—with a delegation of artists of all kinds and the inevitable flock of bureaucrats—as part of an exhibition of Cuban photography spanning the thirty years of the Revolution: from Korda's portrait of Che Guevara right the way through to a postmodern series of the Havana Cemetery by Gory. Every image, including those two poles of the exhibition, were signs of a beginning and an end. Origin and unleashing.

Otherwise, the journey was a bumpy one (bureaucratically speaking), as these countries that had previously been our siblings—the Cuban Constitution began with a declaration of loyalty to the Soviet Union—had begun a slow but irrevocable transition to capitalism.

They were no longer waiting for us.

To them, the Cuban airplane looked like a remnant from their Old Regime. And the Revolution it represented—whose "freedom of expression" in terms of style had been the envy of certain communist states—had become a dinosaur (or perhaps a crocodile) compared to the changes their respective societies were undergoing. The new perestroika bureaucracy—which had inherited this tour from the old Stalinist bureaucracy—didn't know what to do with the delegation, armed and accompanied as it was by our own tropical bureaucracy. The time had come for them to turn toward the West (even though that's precisely where we had come from!) and that plane full of Cubans was a ghost ship from a world that was already beginning to conjugate itself in some form of the past.

I can still remember flashes of it: Solidarity forming a coalition in Poland, Bulgaria's entry into the market economy, carbon copies of all things Western in Prague, a Joan Baez concert—still provocative, it turned out—in Bratislava.

On the trip from Bratislava to Prague, I ended up sitting next to Sergey Bubka—still Soviet, still with that unspeakable red sweater and his down-at-heel style—to whom I spent the hour-long flight talking and whose autograph I got for a friend who was a fan. His poles, naturally, lay along the length of the aisle, as though he preferred to have them to hand should the need arise.

A premonition or a metaphor?

II

In those transitional societies, there was a sense of a return to infancy, with no shortage of stuffed animals or toys. In Moscow, spontaneous orators on Arbat Street apparently felt an uncontrollable urge to shout (the speech itself hardly mattered, the important thing was to liberate the wealth of words pent up inside them for seven decades), while others flocked to the recently opened McDonald's. It was as though they had to learn to speak again (they babbled apparent nonsense), to eat all day long (like kids with candy), even to learn to walk (the borders were opening).

As I saw it back then (as someone who had never been to a "real" capitalist country), the communist world was experiencing not just a transformation but a full-blown conversion. These people were shifting, with shock therapy rather than Vaseline, from communist kitsch to Western kitsch. Just think of the scene of Misha the Bear (the famous Soviet mascot) greeting Mickey Mouse in Moscow's Sheremetyevo Airport.

Something more than a little joke was forged in that hug, in that infantilization so often exhibited by empires. The bear whispered something more serious into the mouse's ear: the New Regime was done with taking a controversial stance on capitalism. As though the sound of cannons aimed at communist repression—richly deserved, lest we forget, given the gulag and the less crude but no less revealing Cuban UMAPs—were hiding a diversion tactic that prevented them from pointing objectively toward the present. As though catharsis, in the end, were enough to start a new life at the end of history.

III

The Berlin Big Bang had its aftershocks on the island. The state had the advantage, though, of having watched the foreign catastrophe from a distance. Other people's rage.

So 1989 ended not just with the communist debacle in Eastern Europe but also with the closure of the most interesting projects by Cuban intellectuals born during the Revolution, who, through culture and art, had called for cultural growth to go hand in hand with a concomitant political opening up.

These intellectuals had never even known Cuban capitalism . . . most of them were sent into exile at the beginning of the nineties anyway.

There was no place for their dissonance in the binary game of Revolution-Counterrevolution, with me or against me, Havana or Miami; it broke with the script predetermined by an ideological field that tended toward black and white.

If they wanted democracy, they could go out into the great capitalist outdoors. If they wanted socialism, they could stay at home. The two things could not be combined. The ideologue behind that exodus concluded that these young people had "a leftist discourse and a right-wing program." In truth, the problem lay not between Left and Right, but rather between the cancellation of a future within arm's reach and a new, unknown future that now had to be imagined.

Or between the old drive to tear down walls that stopped people from leaving and the subsequent reality of new walls that now stop people from coming in.

THE NEW MAN
IN BERLIN
1999–2006

I

In Berlin, among the ruins of the Wall, a Trabant trundles . . .

This artifact from the German Democratic Republic—one of the worst cars ever made, now coveted by Western collectors—slips among the ghosts of communism.

I'm not talking about volatile specters come to trouble our existence, but rather concrete names that interrupt or guide us as we drift through the city.

Rosa Luxemburg, Karl Marx, Friedrich Engels . . .

Archetypes of the Left after whom the streets of post-communist East Berlin are still named. Wandering apparitions who take us by the hand and invite us to walk through the city. Visions of the shifting post-communist manifesto that is the new Berlin.

These ghosts have been disturbed by debates between Jürgen Habermas and Peter Sloterdijk about cloning and the genetic modification of the human species, by the expansion of the internet and virtual reality, by Love Parade and the diverse crowd that wanders through Mitte.

And by the bust of Lenin traversing the Berlin sky dangling from a helicopter (as in a scene from *Good Bye, Lenin!*, the Wolfgang Becker film about the paradoxes of German reunification).

The ghosts of old Berlin have witnessed how panopticons—the interior courtyards of apartment buildings (which delighted Stasi surveillance)—have been converted into shared meeting

places, bike racks, improvised party venues, occasional galleries for alternative exhibitions. And how that surveillance has now been recycled into all manner of cameras, on traffic lights and in banks, in houses and parking lots, in both public and private life. There is a good study of this new form of surveillance by Frank Thiel, an artist who suffered the repression of the old GDR, but who has not lost his nose (or, in this case, his eye) for capitalism's subtlest repressions, and who often responds irately when I describe him as a post-communist. It's the same Berlin that belongs to the handsomely paid Neo Rauch, whose naïve, realistic painting discreetly reclaims certain cultural truths of the East . . .

For any child of the Cold War, moving through Berlin is like making a comeback in a rematch. Because, after all, a subject born under (and for) communism is much like a Trabant. You have to tune up the engine and stock up on Western parts—including dollars and euros—in order to continue on your journey through capitalism. For this post-communist subject, Berlin is a metaphor for a future that was once promised. A fleeting future, admittedly, with the added ecstasy only achieved by cities in transition.

I've heard people say that walking through Berlin at night reminds them of Barcelona during the Underground, or Madrid during the Movement. It makes me think of Havana in the eighties—the Havana Emma Álvarez-Tabío called the "citizens' decade of the Revolution"—when my generation was shaken awake from their dream that change could happen under socialism.

Those cities were undoubtedly going somewhere, but it was the journey—and not the destination—that made them fiendishly free, although they weren't necessarily more democratic in the strict liberal sense. That comeback in Berlin, despite all its paradoxes, manages something even more intense: it gets me

hooked again on the drug of the future. Because, as a delirious Paul Auster character says, "Once you get a taste of the future, there's no turning back."

When I arrived in the bona fide Western world (in my new future), just as the Communist Bloc was collapsing, the philosopher Miguel Morey met me in Barcelona and gave me a little piece of the Berlin Wall. A few days later, with the discretion of a true master, he slid into my pocket an article he had written, whose very title, "Berlin Is No Party," somewhat soured the initial euphoria of reunification.

Since then, I remember that warning every time I visit Berlin. Because it's true, Berlin is not *just* a party. Not even for capitalism. The Wall coming down in Berlin, symbolizing the fall of the Communist Empire, can also be read as the collapse—slower but no less evident—of liberalism as we know it today.

The Wall has collapsed onto both sides. And the democracy we inhabit today—this waning liberal democracy—will perhaps be a necessary but not sufficient condition for the future that social engineering—Francis Fukuyama and his end of history, to give just one example—imagined as a panoply akin to Aldous Huxley's brave new world.

If that fantasy of new capitalism has imploded, it is in large part because the West has failed to listen to voices from the other side of the Iron Curtain. The explanation for this is quite literally pathetic: communism, which was a dreamlike place for many Western leftist intellectuals, has become a non-place for those who lived behind the Wall. Each side has understood utopia very differently: For many of those intellectuals—John Reed, Jean-Paul Sartre, Noam Chomsky—communism was, for most of their lives, a sought-after paradise. For many in the East, however, it was paradise lost. A dream for some, a nightmare for others. Westerners fantasized about an alternative to individualism; for

those who lived in communist states, the problem was that individuality was being stifled.

II

So, as Lenin would say, what is to be done?

Perhaps it's worth appealing to the primary meaning of words. If communism, for Maurice Blanchot, was nothing more than the act of creating community—or better still, an "unavowable community"—we can stick to the factual sense of that phrase and begin our "once upon a time in the East" a little differently.

In any case, parties, too, have their laws, their pragmatic protocols. In the Berlin party we might even find, beyond the euphoria, other answers for today's world. It's possible that the next day, while walking off the hangover, we might think differently about post-communist culture, without abandoning leisure and enjoyment entirely. We might follow the ghost of Paul Lafargue, for example, and try to understand to what extent it is possible, these days, to live out his claim in *The Right to Be Lazy*.

At the beginning of that book, we find Lafargue, taken in by his father-in-law, Marx, proposing to reduce working hours (as civil servants in the European Community have pretty much managed to achieve over the last decade). He also calls for a different organization of work and for a democratization of the process by which everything workers produce is valued. He hasn't yet unleashed the lewd, romantic (not to mention lazy) anarchism that will follow, once he realizes it's not worth fighting capitalism's productivity, or surplus value, or indeed everything that his father-in-law discovered and to which he has nothing new to add.

What Lafargue does give us is a direct attack on capitalism's morality and on its fundamental church, which believes in work as a sacred entity. Hence the quotation from Gotthold Ephraim

Lessing, who encourages us to be lazy "in everything, except in loving, drinking," and, of course, "being lazy." By now Lafargue has stopped worrying about whether or not the working day—the time spent at work—is fair and has moved directly on to specifying things we might do outside that time that do not belong, or at least not entirely, to capitalism. His darts are aimed squarely at the "furious passion for work"—that "intellectual degeneracy," that "organic deformity," that "mental aberration" over which "the priests, the economists, and the moralists have cast a sacred halo."

The Right to Be Lazy contradicts the *Communist Manifesto*'s imperative, "Workers of the world, unite!" and instead offers something akin to "Workers in the same factory, disperse!"

While Marx draws on Shakespeare, Lafargue's more cherished sources are Rabelais, Quevedo, and what he calls other unknown authors of picaresque novels where chaos abounds. It's possible, then, to recover him in post-communism. Because of his reaffirmation of private commitment in the face of the tyranny of the supposedly public (which, after all, is far from being social); because he confirms the individual as capitalism's destabilizing subject; because he understands technology as a liberating alternative—let machines work for us; because of his rejection of the idea that "he who will not work, neither shall he eat," which implies the triumph of bourgeois morality among workers; because of his idea that capitalism subdues by addiction, like contemporary narco-trafficking, since its strategy is not "to find producers and to multiply their powers but to discover consumers, to excite their appetites and create in them fictitious needs"; or because of his criticism of intellectuals who invoke the revolution as long as they do not have to sever ties entirely with their employers.

Understandably, this manipulation of Lafargue's spirit—more romantic than communist, more libertarian than liberal—explodes

as you walk through Berlin, the city that symbolized the collapse of the Soviet Bloc. And it would be no exaggeration to assume that these societies, organized under the supremacy of workers' labor, collapsed because people, quite literally, were tired.

Seen in this light, Lafargue behaves not only like a good thinker but also like a good Cuban. Especially, if we take into account that one of the country's first essayists, José Antonio Saco, took aim at insular thinking with his *Memoria sobre la vagancia en Cuba* (Memoirs of vagrancy in Cuba).

III

Lafargue's subversive trail weaves through the buzzing effervescence of Berlin today, connecting with the fall of communism, an event poorly governed by the Right and poorly assimilated by the Left. Faced with this mismanagement, somewhere between liturgical and lysergic, a punk euphoria emerges, emphatically present, as though tomorrow didn't exist.

It just so happens, however, that tomorrow does exist. In fact, we had agreed we were already there. And no bacchanal lasts forever, because no political body can endure it and no economic body can afford it.

Is this much-talked-of Berlin moment just an alibi for the transition to the normalized morality of capitalism? Or can we find at this party a different bridge to the culture and the society of post-communism?

While we're thinking it over, the Trabant continues on its journey between two worlds. The ghosts that cross its path have questions that can still alter the flow of traffic, even if they no longer have answers that can get us out of the traffic jam.

CALIBAN'S BANISHMENT
1996

I

"Cubans could do with being Frenchified."

Thus spoke Sartre.

It was in revolutionary Havana, in 1960, that he realized Frenchification—real or imagined—would benefit Cuban intellectuals. It would, he thought, at the very least, "distance them from the United States." Perhaps without intending to, the French writer hit upon the key issue shaping Latin American controversies throughout the twentieth century. The battle between Prospero and Ariel, pragmatism and spirituality, mass culture and "high culture," surrealism and pop, the pro-European kitsch of oligarchs in the thirties and the pro-US kitsch of middle-class culture in the fifties.

Like all Latin American culture, Cuban culture has looked alternately toward Europe and the United States when it comes to building modernity. This crossroads, based on the archetypes in Shakespeare's *The Tempest*, have been reaffirmed by the Revolution. Since then, the island's historical subject has often been identified with Caliban, paradigm of barbarism and exemplary rebel, always having to choose between US postcolonial pragmatism (Prospero) and European spiritual colonialism (Ariel).

Hating and needing both.

Thanks to the impact of the Cuban Revolution, Caliban became a Caribbean prototype, composed in three languages by Roberto

Fernández Retamar, Kamau Brathwaite, and Aimé Césaire. All this has been characteristic of the cultural Left since the sixties and is still apparent in many of the multicultural assumptions made in the United States, which so often "barbarize" Latin American— and Cuban—culture in their vindications of it.

Cuban art itself has insisted on highlighting the barbarism implicit in Cuban culture, and in identifying with Caliban, the islander from whom Prospero stole the island and on whom he imposed his language. Since Roberto Fernández Retamar sent him to sea in 1969 (though his *Caliban* wasn't published until 1971), only to recycle him repeatedly until 1991 (curiously, the year when what is known as the diaspora of contemporary Cuban art began), there have been three decades of culture looking avidly toward Europe or the United States to reestablish its archetypes, launch its projects, and build a framework for its journey through modernity.

This paradigm is so powerful that even in exile many Cuban intellectuals continue to renew it. It doesn't matter that in Havana some of them were considered Francophiles, postmodern, urban, "decontextualized." It doesn't even matter that today they spout nonsense about the Cuban regime. When it comes to buying and selling the "exotically correct" identities imposed by postmodern Europe, many return to an archetype they may reject ideologically but whose cultural currency has never been in doubt. Beyond that, it's just a formula in which Cuban culture is summarized as recipes, Afro-Cuban iconography (translated, when convenient, to comply with the audience's tastes), and little else.

These Cuban artists of the postmodern era have discovered that Caliban is an effective companion with whom to engage the First World, but not as was done in the past. His gestures are necessary to enter what Lyotard called postmodern morality: one where we can contemplate our own worst catastrophes in a museum.

This essay proposes a different path. It tries to elude what is taken as given in *The Tempest*; in the vicious circle of an island endlessly consumed by arguments over rebellion, power, and high culture. That is, it resists the idea of a Caliban whose only "profit" from being made to speak a foreign language is that he knows "how to curse," a Caliban confronted by a Prospero who, as well as his enemy, is becoming his sole reason for existing. In this vein, I'll use another Shakespearean resource here—the sub-plot—in order to follow that moment when Caliban chooses to leave the island and cross the ocean, leaving an ephemeral wake in the water. Of course, we're not talking about just any wake, but about a tiny wake in the immensity of the Atlantic. And this isn't just any journey; it's a journey (with or without return) to Europe, a continent that, familiar as it is to Cuban culture, has been immensely difficult to integrate in all its complexity.

II

Cuba is a country with a considerable proportion of exiles— between 15 percent and 20 percent of the population—and an even higher proportion of exiled artists and intellectuals. This has led some to treat Cuban culture like an enormous palimpsest, to use Genette's term, whose interwoven territories span Manhattan and Paris, Miami and Caracas, Madrid and Berlin. So, no matter what is said by the paleo-cultural ideologues who subordinate all other Cuban culture to culture produced exclusively on the island, Cubans have canceled the contract between national culture—whatever that may be—and territory.

The center has been lost. And not only the center of culture produced on the island but also the center par excellence among the exiled. Things can no longer be reduced to Havana or Miami (which are beginning to operate as centrifugal spaces

from which "Cubanness" is escaping); rather, a range of spaces are opening up that are producing culture with Cuban roots or edges, displaced from the old nuclei and often opposed to territorial determination.

Reinvented over and over again, these Cubans are peering into the global village and achieving what the guerrillas of the sixties, when the Revolution seemed universal, never did. Their greatest experience of globalization is, perhaps, in those forms of exodus. And it is these modes which, paradoxically, consummate (and consume) the initial spirit of the Revolution. In this way, the idea of nation, city, any model of belonging, is beginning to break, and Cubans are intervening to a greater or lesser extent in the repeated collapse of the border between the two Americas, the two Europes, the two social systems, the two shores of the Pacific or the continual transgression of the Mediterranean.

In *Mundo soñado* (Dream world), Antonio Eligio ("Tonel") gives us a large mappa mundi made up entirely of Cuban islands. The island, on this map, is everywhere and, for that reason, nowhere.

III

Dominated by the Revolution, the Homeland, Exile, and the Cause, Cubans have been up to their necks in big capital-*P* Problems. That is, they have been living in the presence of history. Their trans-territoriality now offers a way to survive in the presence of geography. So art becomes a map that allows us to navigate and understand the delicate matter of how to exist on this planet. It becomes, in fact, the very foundation of Cuban space, where geography—a science regularly scorned by island modernity—operates as the art of living in the world. That is how it was understood by Martín Fernández de Enciso, who in his *Suma de geographia* (Summary of geography), written long ago

in the sixteenth century, warned us that the book dealt "at length with the art of seafaring."

Thus, the millennium closes with a different notion of Cuban space and borders—with the suspicion that, by breaking the iron contour of the island's border, the tyranny of history over geography has been destabilized. And that any other tyranny, from the island's authoritarian state to the oligarchic power governing those in exile, has been destabilized too.

It is then that the concept of Cuban diaspora—although Fernando Ortiz had already categorized Cubans as "birds of passage"—appeared in the sense it has today. The term is undoubtedly appropriate, both from a cartographical point of view and because it manages to encompass Cuban artists who head out into the world, whether their banishment is definitive or not. Although admittedly, in the ideological sense, the term "diaspora" is used as a cipher for another word the Cuban state doesn't like one bit: exile. Even so, the concept leads us to a series of questions at the limits of Cuban nationhood, modernity, and territoriality.

On this point, Doreet LeVitte-Harten has recommended a reconciliation between artists from Cuba and Israel; two countries that share more than one analogy. Both "possess a pioneering ideology"; they can "consider themselves geographical and political ghettos"; they are surrounded by different or hostile territories that allow them to hold tight to a sense of "us against the world"; and as an aesthetic capstone to these analogies, there is the fact that many of their artists use the body not as metaphor or symbol but rather as a parable of their respective nations.

"They became the land in the same way that Borges's map became the territory."

For all these reasons, LeVitte-Harten insists, artists from these countries could be defined as "somatic-political artists." There are

several non-exiled Cuban artists who have made their bodies into the island, as well as exiled artists who have made their bodies into exile. Or rather, into the traces that exile leaves on their bodies. Here, the body—that place where cultural experiences are definitively inscribed—manages to "somatize" the exodus.

<div align="center">

IV

</div>

All exiles—at least at the beginning of their banishment; at the outset—become travelers. But not all travelers become exiles. A fundamental difference arises, like a wall, between the two groups: the possibility or impossibility of return. Because exiles often become travelers against their will. The story of a journey is not the story of exile but of movement away from and back to the island. The story of exile, on the other hand, is the infinitely varied story of a different kind of journey: of movement from the island to the world. Travelers sail away from home and back. Exiles leave their homes for the outside world. The first is a stress-free, temporary status. In the second, temporariness goes from being a euphemism—they'll come back "as soon as things are sorted out"—to an impossibility. Exile isn't a question of time but of spaces—spaces to be founded, to flee from, to conquer—that do away with the linear chronology of our lives.

The relationship between travelers and exiles in the Cuban artistic diaspora has not been without controversy, and this has brought to the fore the difference between the two statuses.

It could also be said, generally speaking, that travelers have the advantage of state sponsorship on the island and access to the international art market while, to varying degrees, exiles will experience the disadvantages of being outside those two umbrellas.

In 1994, in the alternative magazine *Memoria de la Posguerra* (Postwar memory), founded by Tania Bruguera and published in

Havana (and which lasted only a couple of issues, I should add), certain contributors criticized their exiled colleagues harshly, including how they had—so it was claimed—positioned their work "outside of Cuba." With the "important allowances" that were made for them, their "tendency to commercialize work of little artistic value," and "their conversion into martyrs who postponed their own sacrifice in their rush to attend the 'last call for passengers.'"

This reaction is a way of taking revenge against traditional exiles, who have always claimed the potential (and the right) to speak as insiders of a culture to which they undoubtedly belong. Now, pushing against that tide, Cubans living on the island are speaking on behalf of those outside, including about the topic of emigration. In part because their many journeys have brought them into contact with all of this. And in part because the Cuban art world increasingly feels the need to represent the nation, a need that, as Foucault put it, demonstrates nothing other than the indignity of speaking for others.

Alongside these differences, there have been number of resemblances between travelers and exiles in recent years, years that could well be described as the era of generalized flight in Cuban art and culture. They both attend art fairs (Miami, Guadalajara, Madrid) and group exhibitions that raise the hackles of proponents of official culture. Both manage to fracture the connection between nation and territory; both try to distance themselves from the control centers of Cuban society—Havana and Miami—and, above all, both find themselves at a point of convergence that demonstrates how Cuban culture—whatever it may be—needs to be configured and reproduced differently.

Whether travelers or exiles, all in the Cuban artistic diaspora suffer deeply from the dissolution of ideas about the Cuban nation. Moreover, the ongoing flight—or exodus or banishment

or journey—of these artists, whether temporary or permanent, whether they can return or not, cannot hide the culture's general malaise. Because they are not just fleeing a precarious economic reality (as the Cuban government tends to claim), nor are they driven exclusively by political dissonance (as the powers that be among the exiled would have it). Rather, more than anything else, it's a cultural phenomenon on a fairly dramatic scale. They are fleeing what Adorno called "the damaged life," fleeing a saturated era, an era that has been taken over by politics and continually demands that Cubans take a stance on the project, which also implies taking a stance on death. (Think of the Cuban national anthem, "To Die for the Homeland Is to Live," or the slogans that have accompanied the country's modernity: "Independence or Death," "Homeland or Death," "Socialism or Death.")

Let's face it: the Revolution universalized Cuban culture to the extent that it believes it is the universe itself. That vanity is at the perverse core of nationalism: it dwells so much on its *own* problems that those problems very quickly become *the* problem. It becomes so intoxicated with *its* world that it becomes *the* world (think back to the mappa mundi of *Mundo soñado*). When this happens in small countries, it's pathetically provincial. (There are Cubans who, as late as 1991, even went so far as to say their country produces the best art in the world.) But when this happens in more powerful countries—when it occurred to Hitler, for example—then the universalization of a national problem (our problem is *the* problem; our world is *the* world) turns the pathetic into the tragic, and fascism arises.

I have always assumed—and I have no reason to abandon this idea—that nationalism, to the extent that this is Cuba's problem (as it has been reinvented in the last decade), dissolves the cultural differences between the powers that be in Cuba and those in exile. Ideological discourse aside, both have the same way of

understanding "Cubanness" and of constructing their episte-mology. Both follow the Catholic roots of national identity that we are obliged to accept these days. Both have the master key that allows them to exclude, censure, and expel from the Nation.

There are some who disavow Fidel Castro for political reasons, but who cannot imagine being critical of Cuban culture, though it admits and produces authoritarian archetypes. This kind of dissidence is of no interest to me, nor, I expect, to much of the so-called nineties diaspora. However, locating the act of fleeing—the diaspora itself—as a Cuban condition, when it is also a global situation, involves running away from this plot, leaving home for the great outdoors, the island for the world, the village for the open ocean.

After Fernando Ortiz, to talk about the Nation is to take a step backward, to retreat into the lair of the white-creole-Catholic-ethical paradigm. It is to take refuge in the national bourgeoisie's last attempt to synthesize the Nation (from José Martí's "with everyone and for the good of everyone" to Ortiz's own metaphor of a great vegetable stew containing every possible ingredient).

The Revolution—which excluded its detractors—opened up the possibility of a world without synthesis. And this is the great trap of the return to the discourse of the Nation by the Cuban state and today's organic intellectuals. It implies a nonrevolu-tionary synthesis, in the same way that the Revolution implies a nonnational exclusion. That's the paradox of the malaise of Cuban culture.

V

In his old age, when Fernando Ortiz was asked about his health—"How are you, professor?"—he would respond simply: "Still here, hanging on." In 1991, when someone in

Cuba was asked the same question, they would reply without a second thought: "Still here, escaping." These two responses define, perhaps, the philosophies of nationalism and flight from nationalism. The Cuban Nation reached its climax in the epistemology of Ortiz, for whom the important thing, undoubtedly, was "hanging on." The diaspora Nation is a nation that is fleeing, both physically and culturally, where survival involves a direct escape. The point isn't the enduring, unchanging slogan of capital-*I* Identity, but the transitory nature of the journey, the mobile status of the "escape." It's breaking with the choice between the Cuban extremes ("Homeland or Death"), heading in with neither one nor the other, to risk your destiny in the cultural forms demanded by the new millennium.

That *escape* constitutes, in recent years, Cubans' greatest experience of cultural globalization, as they join the troops of what Sloterdijk has dubbed the "last men," faced with the thorough discrediting of the old ideas of Homeland and Exile, to reinvent the country, banishment, politics, art, and the world order. A globalization in which they integrate into the universe with great difficulty but at least—as Shakespeare warned in *The Tempest*—with "sea-room in which to maneuver" freely.

In his book *Deseo de ser piel roja* (The wish to be a Redskin), Miguel Morey explains that the New World Order is governed by two models of confinement and seclusion: Native American reservations and concentration camps. So we should take no comfort from the naïve idea that we live "after Auschwitz," because Auschwitz has not gone away. It is here and "now populates the entire earth." Morey suggests that in a world like this one there is a possible homeland, and it is called Escape. In another recent book, *In the Same Boat*, Peter Sloterdijk notes that in the territories we choose after leaving behind our homeland and other belongings, the foundational possibility of our time is sealed.

"These social islands or rafts will once again become the birth-places of psychocultural characteristics that one day will produce global effects."

If all this were at least minimally possible, Cubans who inhabit the territory of exile and travel—of Caliban's subplot—would sail like argonauts from another cultural system, Cuban and post-national, insular and global, whose art will consist of activating escape as a different way of living and reproducing culture, society, and people themselves. Crew members on the hunt for the next shore, ready to swell the ranks of that wounded but distinct culture, the culture of those whom Hugo of Saint-Victor thought bordered on perfection: those for whom "the whole world is like a foreign country."

MIAMI, AFTER CHRISTO
1994–1997

I

In 1983, Christo—the French-Bulgarian artist—"wrapped" eleven cays in Biscayne Bay, Miami. It was a surprising gesture, in the Sunshine Capital where Latin Americans have built an upside-down utopia based on projecting the past into the future in order to bring to life the vernacular dream of mixing the pleasure of the tropics with the advantages of the First World, the speed of motorways with a Latino tempo, Celia Cruz with the American Dream . . .

Chicanos base their claim to the US West on the idea that the mythical land of Aztlán was discovered there, but no such story is told about Miami. There the aim is to reconquer not space but time: the time of Eternal Youth, which Ponce de León already sought there some five hundred years ago.

Around those cays that Christo wrapped, then, grows a city that is also a reproduction (a theater prop) of the lost country. That's why you'll find Little Havana and Little Haiti there, whose prefatory "little" indicates not the size of the neighborhood but rather (as Gustavo Pérez Firmat noted) that they are incomplete copies of the original.

Disregarded by liberal capitals in the United States (Boston and New York); scorned by progressives who admire (from afar) Latin America's "authentic" guerrillas; sometimes censured by Cubans in exile in Europe (who are terrified to look in that mirror because

it reflects their own image), Miami has been considered second rate, a kitsch mecca akin to somewhere like Marbella.

My various travels, however, have shown me worlds that go beyond these clichés, or rather, hide behind them.

Miami has afforded me a strange experience. I may not have found the Fountain of Eternal Youth, but I did find that time stood still there; I may not have found all the things absent from my life for over three decades, but I did find some absentees (in the flesh); I may not have found easy money, but I did find some. I may not have recognized my home country there, but I did find a replica of it.

In Roger Bartra's *La jaula de la melancolía* (*The Cage of Melancholy*)—his takedown of Mexican nationalism—he considers the bucolic state of the soul. A feeling that precedes modernity, where stillness and the countryside are center stage; it's a time that differs from our own, so dependent on the speed of urban life. The cage of melancholy is a prison in which, according to Bartra, Mexicans have been trapped, gripped by imaginary networks of political power, which eventually involve them in the fiction we have come to know as "national culture." In Cuban Miami, the feeling animating this sketch of identity isn't really melancholy but rather nostalgia. And it responds more to a bodily state than to a state of the soul.

It's not that Cubans don't have a soul (indeed, an advert for Havana Club tells us that rum is the Soul of Cuba), but the sense of nostalgia that emanates from Cuban Miami comprises smells, tastes, sounds, sex acts—in short, senses that involve bodily territories rather than ethereal realms.

"Nostalgia sells."

This is the first thing you'll hear from the merchants of patriotism who do their rounds there. And so each generation of Cubans adds their own strange layer of nostalgia to the sweet, collapsing cake of national culture.

Nostalgia is the title of an Andrei Tarkovsky film in which an artist wanders through Italy with both his head and his heart full of the country where he was born. It's about the unchanging Russian soul, which even exile cannot fracture, undertaking a journey. And Nostalgia is also the name of the bar founded by a Cuban ex–cinema director as the latest escalation of this method of promoting "Cubanness." The bar is a kind of anthology of nostalgia. Only that it doesn't exclusively recover nostalgia for the fifties-esque capitalist culture of the Historical Exile Community; rather it includes everything, even the communist period, which is integrated perfectly into the past, a past becoming known as "the world that has been and gone." In this sense, one of the most interesting aspects of Miami is the number of people there who were educated under a communist regime (the Cuban regime) and who today are settling in as the city's leading lights. Renowned painters, businesspeople, academics, radio presenters, famous musicians, and a long et cetera. All this makes Miami a post-communist city, a claim that would horrify the Cuban far right or the WASPs themselves, who are making a strong comeback in the United States.

As if any further proof was needed, the existence of food stamps and the Cuban Adjustment Act are the cherry on the cake of living out the Cold War under capitalism.

On a visit to the working-class city of Hialeah, which has the highest concentration of Hispanic people in the United States (around 98 percent), I bought some glasses that represent the excesses of patriotism. They have Cuban flags on the lenses, so your vision is very limited, and always in the national colors. This is the height of Cuban nationalism in Miami: it protects you and, at the same time, blinds you.

II

The "politically correct" functioning of the state of Florida is guaranteed by this flag-waving gaze. A curtain drawing the "Cuba problem" over the "Miami problem." The former involves the Cuban government–exile–US administration triad. The second involves distinct worlds, dozens of official and unofficial languages, religions, and nationalities, all apparently controlled by a border imposed by the First World in order to contain the Third.

That is the other obsession of this last bastion of the Cold War: to stop, by any means necessary, the periphery from crashing in an avalanche onto the very center of the world. When the Cuban problem's own particular Berlin Wall falls, perhaps the other wall dividing the First World from the Third will also come down; the curtain will be drawn and we will finally take off our patriotic glasses.

Meanwhile, Miami will remain an archipelago whose little islands are joined by motorways that cross, without touching, the many ghettos that compose it: Little Haiti, Miami Beach, Liberty City, Downtown, Coral Gables, Hialeah, the Southwest . . . They should really have a Robert Venturi over there to give us something like *Learning from Las Vegas*. There are cities where everything is explained by bodies (or by music or literature or nightlife). In Miami, though, almost everything is contained in its architecture. In that ambiguous mix of stable exteriors with inconsistent interiors. This paradox of construction tells us everything.

On Ocean Drive you'll find the most perfect bodies in the world as well as limousines full of self-satisfied fat people; you'll find macrobiotic diets beside extreme gluttony; Marielitos beside the old Cuban bourgeoisie; Old Left beside nouveau riche; indiscretion beside silence; hordes of gay men on the beach beside a barbershop where Fulgencio Batista is considered a god.

Perhaps a version of Venturi would have discovered that Miami is not a reproduction of Havana but a kind of Ridley Scott's Managua. A multi-peripheral space without a center. An atom-ized city in which we never quite get to where we're going. A non-city city.

There are intellectuals and artists there with a somewhat belated devotion to Jean Baudrillard. And though the city is full of hyperreality and simulacra, I never really understood this frenzy for the philosopher of the *after*. Contrary to what Baudrillard proposes, Miami seems not like a place where everything has already happened, but rather a curious archipelago where things are always *about* to happen, in the days leading up to something. If Miami operates like a black hole, absorbing everything, it's not because people there are living *post* something, after everything that has happened, but rather because there is always this sense that something is yet to come: the fall of Fidel Castro, integra-tion into the First World, the apotheosis of mestizaje (which has not occurred, despite every opportunity for mixing to be found there), the arrival of the weekend to be enjoyed "Latino-style" after a week of working "Anglo-style," the winning lottery num-bers to be announced on Saturday . . .

In Café Tu Tu Tango on Coconut Grove, a painter whose nationality I never learned asked me to write, like Baudrillard, some "cool memories" about Miami, which he adores. It was right at the moment when I discovered the existence of the ropa vieja pizza (topped with a traditional Cuban dish of spiced shredded meat), and promptly ordered one. The café in question wasn't even Cuban.

"You have to refer nostalgia to the future."

That's what the artist told me.

And right there he taught me another lesson: in Miami, even the past is yet to happen. Being there, you sort of transcend what

has happened and keep it on your horizon. Basically: "Back to the future," whether through a pizza, a mobile phone (so you're always connected to the system), or a government program.

III

A friend—another painter—discovered my true multicultural experience on the pedestrianized part of Lincoln Road. We were in this place that could have been an antiques shop, a gay bar, a Japanese restaurant, an art gallery, or all those things at once. He asked that I return to the tone of my early texts about this city, which he hates. Meanwhile, the painter I didn't know was insisting on those "cool memories" and the Baudrillard plan.

A few meters from this literary salon, Gianni Versace's designs were inspired by the art deco of Ocean Drive, by the bodies of roller skaters, by the perennial pink of the beachfront avenue. His inspiration was cut short one morning in 1996 by two gunshots.

His remains left a stain (red, not pink) on the front door of his house. As though to mark the end of my voyage of discovery that began with Christo and ended in blood.

NIGHTMARES IN MIAMI
1998

I

In March 1997, Pedro Medina, a prisoner of Cuban origin, was electrocuted on murder charges in a prison in Tallahassee, Florida. That day the electric chair (known as "Old Sparky") malfunctioned, and the spectacle of the execution achieved moments of cinematic gore when several shocks were needed to complete the prisoner's death sentence.

Around the same time, the pop star Madonna gave birth to her first daughter, whom she called Lourdes María and whose father, a Cuban named Carlos León, was Madonna's young and athletic personal trainer. The news of the performer giving birth and of Pedro Medina's death (which was itself an appalling performance) would have had no special connection except that there were two Cubans involved (these days of course you find Cubans wherever you least expect to). There is, however, one point of contact between these two events: Pedro Medina and Carlos León both left Cuba in the spring of 1980 on the Mariel boatlift to Key West, along with another 125,000 Cubans who were expelled from their country as the personification of "scum."

These two events led the group philosophy to flourish once more among the Marielitos. While some showed undisguised pride that Madonna had had a Marielita daughter with "one of our own," Juan Abreu concluded that Pedro Medina had been electrocuted because he was "poor, black, and a Marielito."

These news items offer an interesting parable of the two extremes within what has come to be known as the Mariel group. Although it would be more accurate to say that the Mariel group itself is the extreme; the unclassifiable edge of Cuban culture that has in many ways yet to be deciphered.

From a creative point of view, the Mariel Generation has tackled fiction, visual arts, poetry, music, journalism, academia, and theater. And its members live and work in cities as diverse as Miami, New York, Madrid, Albuquerque, and Chicago.

When we think of the Mariel group as an intellectual movement, we tend to spotlight Reinaldo Arenas and sometimes the painter Carlos Alfonzo—who rightly deserve the attention—but others in the group have also produced important works in their respective areas of creativity. Take, for instance, Carlos Victoria and Guillermo Rosales (fiction), Alfredo Triff and Ricardo Eddy Martínez (music), Raúl Ferrera-Balanquet (video art), José Varela (caricature), Juan Boza (painting), René Ariza (theater), and Esteban Luis Cárdenas, Andrés Reynaldo, and Roberto Valero (poetry).

The Marielitos were not raised up on a pedestal like the masters who made their careers before the Revolution, nor did they have the contradictory glamor of those born after it; they were trapped with no way out, stranded between a communist government who threw them out of the country because they didn't fit into its perfect, utopian future and a community of conservative exiles who did not fully accept them, because they didn't fit into their fantasy of a perfect past.

There are still other contradictions that set the group apart within Cuban culture. Regarding their relationship to the Left, we have to remember that the Mariel boatlift coincided with a timid attempt at rapprochement between part of the exile community and the Cuban government (the dialogue that took place in 1979

was depicted in the documentary *55 hermanos* [55 brothers], directed by the filmmaker and novelist Jesús Díaz). No matter how you look at it, the Marielitos complicated the arguments put forward in that dialogue: If Cuba's revolutionary project had really achieved the successes in education, social justice, and civic life recognized by that fraction of the exiled community, why was the country producing such an extraordinary amount of "scum," willing to do anything to escape a communist paradise? And on the other hand: If the boatlift had brought over not just "scum" but also intellectuals, professionals, students, and honest workers, why were so many "normal" people deserting and thereby undermining the image of a revolutionary Eden?

Given this dynamic, the group's arrival in the United States did not help much either, because the claims of their most combative members—especially Arenas—brought about a bitter controversy between the existing exiled Left and the more radical of the Marielitos.

II

Things didn't go well for the Marielitos with the Cuban government, nor with the left-wing members of the exiled community, but they didn't go much better with traditional right-wing exiles either. The Mariel boatlift brought the conservatives face-to-face with the reality of a country very different to the pristine, bucolic nation lingering in their imagination. Now, all of a sudden, it turned out that the Cuba of their dreams was also mestizo, sexually indiscriminate, iconoclastic, and plebeian. An image that the nostalgic mirror of Miami had wanted to forget.

Two novels include exemplary depictions of this misunderstanding: *El portero* (*The Doorman*) by Reinaldo Arenas and *La casa de los náufragos* (*The Halfway House*) by Guillermo Rosales.

In the very first pages of *El portero*, Arenas attacks an early exile's reservations about a young Marielito recently arrived in Miami:

> And what did you expect? Should we have offered him our swimming pools? Or, just because of his pretty face [...] were we supposed to have invited him into our mansions in Coral Gables? Or to have handed him the keys to our latest-model cars so he could win the love of our daughters, whom we have raised with so much loving care? In short, should we have let him enjoy the good life without first having learned the price one has to pay in this world for every breath of air? Not for a minute!

La casa de los náufragos describes the life of a writer (no doubt Rosales himself) who arrives in Miami fleeing Castroism but then, when he is unable to adapt to the new reality, is cut off by his family and ends up in an asylum for the helpless and insane.

"They were expecting something great. They got me instead."

Not even Hollywood could resist the marginal stamp of Mariel. Hence *Scarface*, Brian De Palma's remake starring Al Pacino, describes the story of a Marielito who becomes a successful drug kingpin. Many exiled Cubans were outraged by the film because of its negative depiction of their community—especially its violence, drug addiction, and incest—and the sleaziness of the main character. That said, all this shows considerable amnesia. (How could they forget that the nineteenth-century novel *Cecilia Valdés* laid the foundations of Cuban fiction with a plot full of incest and violence?)

III

The uniqueness of the Mariel group in Cuban culture is rooted more in its non-place than in its avant-gardism, and its discourse

is situated precisely on the border between the Stalinism of the seventies and the relative openness of the eighties, which brought a radical negation of previous poetics. In the seventies, a Stalinist philosophy (or something like it) was used widely in Cuba to explain the art that was produced there, while the eighties brought with them a body of ideas belonging to postmodern poetics. Thus, the artists and writers in the Mariel group were stuck on a beach with no way out, between the modern, dogmatic world of the seventies, with their commitment to official authority, and the more cynical world of the postmodernists that was to follow. That dislocation in Cuban culture has other explanations that can be seen in the extreme—and extremist—forms that the group's discourse often took. The radical anti-communism of many of its members (let's not forget that the Berlin Wall was still standing) led them to share, passionately, certain aspects of the official exile community's rhetoric, despite never being entirely accepted there. At the other extreme, there was no shortage of diatribes against the old Cuban oligarchy—labeled the "bourgeoisie," "the elite," "the ruling class"—which approached revolutionary orthodoxy.

These positions are not unwarranted. The Mariel Generation lived through a dramatic experience in an extremist Cuba, and their exit from the country—reviled and assaulted by mobs in so-called acts of repudiation—was undoubtedly the most traumatic in the history of the Revolution. When you've lived through situations like that it's no wonder you end up becoming radicalized. And if we read the magazine *Mariel*, it turns out the philosophy animating the group was "foreign" to Cuban culture on its other shores too: the Marielitos' work was indebted to Sade and Djilas, while their more national explorations made them devotees of authors who were prestigious, but little accepted at the time, such as Eugenio Florit and Lydia Cabrera.

IV

The Mariel Generation should not be understood exclusively as the group of artists and writers who took part in the events at the Peruvian Embassy in Havana and the subsequent exodus from a port west of Havana accompanied by the cry of "out, scum!" Chronologically speaking, the precursors to *Mariel* magazine can perhaps be found in the precarious, clandestine literary salons held by various members of the group in Lenin Park, as Reinaldo Arenas pointed out in *Antes que anochezca* (*Before Night Falls*). As time has gone on, the group has gained members; they have joined a project that has neither wanted nor been able to institutionalize its cultural and political experience.

When I first began to publish reviews about this group, I regularly found whole libraries of unpublished books in the homes of Marielitos. They were written without hope of seeing them released on the Hispanophone market because—and here they are once again out of joint—they continued to write in Spanish even in the United States. The Marielitos had no Ry Cooder to rescue them and make them stars or compensate them for their miserable history. They were too difficult, they weren't exotic enough, they didn't deal in nostalgia—they weren't reinventing magic realism, their artists never corroborated any of the theses proposed by the troop of curators launching themselves at Cuban art. They even seemed to enjoy their perpetual isolation and, for a long time, few critics approached the group, complicated, controversial, and tumultuous as it was. At a time when Cuban culture was being nauseatingly sublimated by Cuban and Cuban American writers who subscribed to multiculturalism, the Marielitos' stories were not about "dreaming in Cuban" but about nightmares in Miami.

But for me this broken image was what was truly fascinating about them: the accumulation of their paradoxes, the coherence

of their contradictions, the diabolic romanticism emanating from their stubborn insistence on making art, not quite despite their rough circumstances, but rather because of them.

The Mariel group held a mirror up to the Gulf Stream, and with the splintered image that it reflected also subverted the political, cultural, and everyday uses of the Cuban Revolution and their exile. They were, perhaps, the only successful invasion during the tense relationship between Cuba and the United States (and between the island and its exiled community). But the invasion was successful to the extent that it sided with no one and destabilized everything. It was, more than anything, erotic, given the urges and spasms it created. Like a savage and unexpected apparition, it was stronger than the Havana guerrillas fighting the Empire. And it was stronger than any armed mercenary troop from the US coast to the north, because the Marielitos fought only for themselves.

In 1980 the Revolution was less revolutionary than ever, and exile was closer than it ever had been. It was then that the wall every Cuban had built, endured, and transgressed over the last forty years began, violently, to break apart.

TRACES OF A BODY OUT
IN THE OPEN
1998

I

The image comprises five figures. Mother, father, and three children who are not looking at the camera. The photo has no background. This isn't because they are standing against the neutral wall of a studio, but because the figures have been cut out and all that remains of the photo's original composition are five bodies stuck onto a white piece of paper. I'm looking at this photograph on Long Island, twenty years after it was mutilated by Cuban customs officials, who classified this family's patio as a "strategic zone" and therefore of interest to the enemy. It has been two decades since these people watched their family album be cut to pieces before they went into exile; two decades since the authorities destroyed any possibility of archiving a tiny space that would serve as a reference or anchor for the people whose faces are now floating in the void. They were left like ghosts without a landscape, drifting out in the open. Bodies without a country.

The photo belongs to the family of a friend whose letters and messages gave me the key to understanding exile. Before I stumbled upon them, I went through phases of wanting to quit—of resolving to give up first one thing then another. Phases of wanting to abandon being Cuban, and then periods when I was driven by the desire to abandon writing. I'd appropriated one of Borges's well-known phrases, which led me to assume that being Cuban (or Argentine, or Mormon) was an act of faith.

Only, that faith had ceased to accompany me, and I was passing through different realities—Mexico, Miami, Barcelona—where I didn't feel fully integrated (a word with fascist connotations that I find alarming). My story is one of extensive involvement in several places and at the same time intense alienation from them all. The latter I could nurture through the way I have lived out my exile—through the fact that my Cuban condition (whatever that might be) was never a job or a means of putting food on the table. So my spells of wanting to forget all things Cuban were sustained by relative (although very modest) success in supposedly foreign subjects. Having left Cuba, I was writing about other places—turning my back on the country. Meanwhile, the economic hardships of recent emigration, my own stubbornness, and my education stopped me from looking back too often. I justified all this with the knowledge that, even before I left Cuba, I was devoted to questions of postcolonialism, peripheral cultures, and the impact of postmodernity on Latin America. But these were intellectual justifications that didn't tell the whole story. In reality, diaspora only exacerbated the sense of uprootedness for which I was already prepared before I set off on my journey.

Other things affected the way I lived out my exile. I realized, for example, that while I hadn't exactly covered myself in glory with what I had written about Cuba while inside the country, neither did I have to rush to "clean it up," nor was I obliged to repent thoroughly and intone a mea culpa. I wasn't obsessed with being agreeable to the Official Exile Community either. I never had a patron among the gurus of official island culture and have not therefore felt the need to look for a substitute in exile who would protect me or help me establish a "Cuban career."

To all this I should add that I do not see eye to eye with recent prophets of Cubanness; that I have an affinity with post-national forms of contemporary culture; and that I have criticized—ever

since my years in Cuba—what I consider to be the epistemology that founded and maintains so-called national culture, that *theology of the nation* presented as a theory of culture (and whose trajectory can be traced from the first Presbyterian, Félix Varela, to Cintio Vitier). What's more, I have never communed, culturally speaking, with the merchants of nostalgia and those who built the model village that is Miami, but who are no strangers to Madrid, Barcelona, Paris, or Stockholm.

The fact is that my days and my writing slip between Cuban subjects (or Cuban-adjacent subjects) and subjects like Orlan or Camille Paglia, Werner Herzog or Guillermo Kuitca, Octavio Paz or Marcel Duchamp. I will probably never belong to them but I'm certain that *they* belong to *me*. And that the landscape where my body can be traced is vaster, more mobile, more assimilable or disposable, to the point that it allows me to touch what liberalism, existentialism, or Marxism have denied us, and which once appeared to us on the horizon as freedom.

In former times, this was a fairly widespread way of being Cuban. But today, in this global era that has put a pair of maracas in the hands of everyone who emerges from the island, such a position looks like stubborn resignation, snobbish pedantry, or antipathy, and it turns anyone who holds it into a kind of Uncle Tom devoted to enemy values (though nobody knows exactly which values nor which enemies). A unique Uncle Tom whose cabin is suspiciously open to Uncle Sam.

II

Cuban culture has been blown up. It has shattered into many fragments, become what Antonio Vera León called "cubist Cuba."

This Big Bang has global detonators in the fall of the Berlin Wall and the aftershocks that have rippled around the world

since 1989. But what we now call the Cuban diaspora has its own starting point in 1991, the year when an important number of artists and writers born with the Revolution went into exile, this time scattered among cities like Mexico City, New York, Madrid, Barcelona, Moscow, Caracas, and Paris. An exile with as many determining factors as cities where it is being lived out, leading someone to baptize it a "low-intensity" exodus or a "velvet exile."

I have never agreed with these labels, so applauded by certain members of the exile community to their own benefit. Perhaps because, in my particular case, I've known a lot of exile and very little velvet. Almost everything in a diaspora is designed to fail and you soon discover that for us the fifteen minutes of glory decreed by Andy Warhol become fifteen minutes of . . . Gloria Estefan.

When I write the word "diaspora" I cannot limit it to the space outside the island, just as when people talk about Cuban culture they're not talking exclusively about culture produced on the island. Otherwise, how are we to understand Kcho, Cuba's most internationally recognized visual artist, dedicating his aesthetic almost exclusively to rafts, or the magazine *Art in America* revealing, in its roundup of 1996, this unique fact: that most Cuban artists whose work is exhibited in New York live on the island of Cuba, not off it?

Mine is, in short, the story of a great scattering through space accompanied by a quiet relinquishing of nation. It's not that I don't remember the years I spent in Havana, just that I find no reason to harbor any fundamental nostalgia for them. Among other things, because my memories—vital, erotic, intellectual—are today spread out and lost among a nameless alleyway in Managua, in a sobering encounter on the banks of the Mississippi, on some late-night journey along Miami Beach, on a boat one strange dawn in Acapulco, in almost every bar in Barcelona, and in Madrid's somewhat decadent nightclubs, which are nonetheless close to my heart.

I know how intense Cuba is. I, too, lived through some very difficult days in Havana, as well as the corresponding night shifts. And even today I still enjoy my old habit of collecting absurd headlines, found lying around by my books, my music, my dog, or my parents. I, too, read sports stories with philosophical headlines: "Socrates Says Coming to Cuba Is No Problem." Adverts for food that seem to be from the sporting world: "Pollo Piloto's Friday Triumph." War reports—in this case the digging of trenches all over Havana—that revealed the Maximum Leader's gourmet tastes: "Fear Not, Comandante: We Will Make Havana a Great Gruyère Cheese." And a carpentry advert that painted a vision of a frightening future: "For Sale: Square Children's Playpens."

All this left me transitioning chaotically from a son of Utopia into a kind of father of Atlantis.

The diaspora in which I live and write registers a geographic overflow previously unknown to Cuban culture. It is the multiplication of exiles to every part of the world, but also the growing activity of non-exiled Cubans. Both sides have fractured their old Cold War and entered a kind of hot peace that is leaving behind the fundamentalisms as well as, let's not forget, the great wounds of the past. This has been like the gradual escalation of flirting: First they saw each other at some gathering but kept their gazes averted. Then the glances and eyelash fluttering began. Now we are abundantly promiscuous, exhibitionist in private but conveniently hidden in public.

III

Today we hear of a Babalawo who scrutinizes the future in Tokyo, while at the Egyptian pyramids a Cuban rents a couple of camels that he soothes in Arabic and scolds in a Havana accent. The internet suggests websites that range from patriotic throwbacks to

collections of anti-Castro jokes. And there is news of paladares—
family-run restaurants—opening in Madrid, Vigo, and Barcelona,
the last also home to a brothel whose exclusively Cuban prosti-
tutes provide the city with erotic solace.

The diaspora also involves a subversion of the racial order: an
exile community that in the early years was mainly white, con-
servative, traditional, and rarely short on racism, has become
darker skinned since Mariel and the boat people arrived. In front
of the Dakota building, where John Lennon lived and died, every
summer there's a Sunday rumba, where a group made up mostly
of black Marielitos, boat people, artists of my generation, and
Spanish people desperate for a taste of Cuba, line up to hear a real
guaguancó rumba.

Meanwhile, Daína Chaviano, a Cuban writer from Miami, feels
she is heir to the Celtic tradition . . .

Diaspora also brings, needless to say, structural overflow:
despite the efforts of publishing houses like Verbum, Playor,
Betania, La Torre de Papel, Colibrí, and Universal, the Cuban exile
publishing world, especially in Miami, is insufficient, and other
non-Cuban publishing houses are making up the shortfall. This
has a significant impact on literature, because it means Cubans
are obliged to write with a wider range of readers in mind, many
of whom already have a fixed idea of what their culture is like.

Something unheard of in previous eras is the change in cri-
teria according to which positive values are attached to the island
and negative ones to exile. These days you might stumble across
a copy of *Encuentro* magazine in Madrid and publications with
names like *Contracorriente* or *Diáspora(s)* in Havana.

Diaspora also sparks the possibility of foreignness, multiplicity,
and alternative outlets for Cuban fundamentalisms. Don't be
fooled: beneath the tourist image of a culture dressed up for car-
nival, there is often an unrepentant tendency toward the extreme,

including necrophilia itself. In the first case, there are the poles of a culture that prides itself on having a Maximum Leader (all other leaders are minimal), a Leader of the Free World (the rest of the world is in chains), as well as a vast nobility, plagued by monarchs like the Queen of Salsa, or, if you parade down Miami's Calle Ocho, the Pizza King, the Ponche King, and the Frita King. As for necrophilia, it's a similar definition throughout the history of the Nation: the project or death. I'm not talking about insularity's extreme metaphors (though they should not be ignored either): Utopia or Atlantis, freedom or captivity, prosperity or downfall, breeze or cyclone. I'm talking about slogans with undeniable staying power: "Independence or Death," "Homeland or Death," "Socialism or Death."

Cuba's national anthem concludes with a resounding "To Die for the Homeland Is to Live."

This reminds me of two poetic responses. One by Ramón Fernández-Larrea in Cuba. The other by Gustavo Pérez Firmat in the United States. The first was writing in the eighties:

> To die for the Homeland is not to live,
> It is to die for the Homeland.

The second wrote the following, in North Carolina:

> Bayameses, I have news for you
> To live without the Homeland is also to live.

Although they might seem heretical, these poems are written in a tradition of suspicion of the national anthem, which they share with none other than Nicolás Guillén:

> Run into combat, Bayameses

> *Why aren't we all running together?*
> *I've often asked myself.*

My understanding of diaspora is based on a physical and, in large part, historical change. I have always thought that one of the keys to modern Cuba's relative political stability has to do with the way the masses perceive leaders as temporary despite their persistence in positions of power. Throughout the twentieth century, Cuba has seen several versions of authoritarianism along with their respective ideological variables, social systems, and degrees of dependence on foreign powers. These forms of domination have included conservative, liberal, and Marxist proposals. The island has known the scourge of democratically elected dictatorships, like that of the liberal caudillo Gerardo Machado; exceptional coups like that of Fulgencio Batista—who had previously governed by the ballot box in alliance with the communists—and a communist-style regime in which the same leader spent some six years in opposition and then some forty in power.

Half a century.

So you might think one of the keys to the relative stability—or absolute freedom to maneuver—that Cuba's authoritarian regimes have enjoyed is rooted in the fact that, throughout the century, society has always had the secret hope that, at critical moments, our caudillos would abandon the island. It's what happened with Machado and Batista, who escaped just at the right moment, though not before filling their luggage with stolen money.

The current situation differs radically from that tradition. There is no indication that the current political leader will abandon the country, save in Manuel Fraga Iribarne's late-Francoist dream. The Leader will not leave; rather the country, the

nation itself, will enter a phase of fragmentation, which was taken to its maximum expression during the boat-people crisis in 1994. It looked—from a bird's-eye view—as if the island were breaking apart, reproducing itself in the sea-foam like an immense archipelago at the mercy of the Gulf Stream, sharks, and the US Coast Guard. As though a single, unmovable center had tightened the screws so much that the whole country shattered into pieces. It's a situation Reinaldo Arenas anticipated in his futurist novel *El color del verano* (*The Color of Summer*), which is set in 1999.

My understanding of diaspora also involves the decline of what was previously known as the capital of exile, Miami, as well as the loss of its specific weight in Cuban culture. The traditional Cuban exile community still has anti-cultural prejudices, a kitsch, nouveau-riche aesthetic that is integrated into modernity via the mall, the cell phone, and the internet, but not the critical approaches modern culture brought with it. Cuban diaspora culture, for its part, unfolds within a vast, disproportionate space—undoubtedly a good thing—but a minuscule institutional structure. Thus, diasporic writing is a mosaic of literary spaces that are not only obliged to escape from the Official Island but also pressured into leaving the Official Exile Community. It is no coincidence that Guillermo Cabrera Infante lives in London, Antonio Benítez-Rojo in Massachusetts, and Jesús Díaz in Madrid. Nor that Lydia Cabrera lived and died, unappreciated, in Miami.

If any condition can be salvaged from Cuban culture, it is its migrant character. African diaspora, Spanish diaspora, Chinese "coolie" diaspora . . . There has always been a diaspora, to the extent that Fernando Ortiz, who played a key role in the formulation of a national model, referred to Cubans as "birds of passage."

IV

Writing and diaspora reflect the many options in literature at the turn of the millennium. From reckonings with a revolutionary past—Jesús Díaz in *Las palabras perdidas* (The lost words) or Eliseo Alberto in *Informe contra mí mismo* (Report against myself)—to pieces about the dismantling of national culture, like those by Reinaldo Arenas. From formulas for the recovery of a lost country—which Guillermo Cabrera Infante has turned into a poetics—to a heartrending vivisection of exile like Guillermo Rosales's *La casa de los náufragos*, perhaps the most powerful novel ever written in Miami. From urban groups at odds with their environment—as in the case of underground literature from Miami and other parts of the United States, principally by authors involved with *Mariel* magazine—to José Manuel Prieto's *Enciclopedia de una vida en Rusia* (*Encyclopedia of a Life in Russia*). From writers immersed in other languages—Gustavo Pérez Firmat or Eduardo Manet—to those intent on seizing the Cuban language at all costs, as though it were an invariable substance, as happens in the poetry of José Kozer. From bildungsroman-style sagas—Carlos Victoria—to authors trying to restore national culture before it shatters completely: Rafael Rojas, Abilio Estévez, Mayra Montero, Antonio José Ponte . . .

This diversity, unfortunately, has not been entirely accepted by specialists, editors, and critics. Cuba's success stories have needed seasoning with bucolic condiments, suitable for tourists and thoroughly watered down with banality, tambourines, and commonplaces. Cubans are often depicted in the same way, much like gay men are depicted exclusively as feathered queens, Catalans as stingy, Andalusians as lazy, and lesbians as truck drivers. Let's imagine—just for a moment—that in Mexico there is a Spanish publishing boom based entirely on bulls, flamenco hair-

pieces, and famous folkloric actresses. How would critics react to this boom and the messages it was sending?

The publishing world's current most widespread cliché—fueled by a considerable number of emerging "exilologists" from the island—is to claim diaspora literature as nostalgia. There tend to be two strategies: The first is nostalgic for a time, locating the magical origin of Cubanness in a sugared version of pre-revolutionary Cuba. The second is a kind of nostalgia for space, by which I mean for the island's very immanence, an island that, despite all its catastrophes, will always have its authenticity, its superior people, and a culture that persists, unchanging, despite all the island's vicissitudes.

This ends up turning literature into a service, typical of a tourist economy, with folklore, neon lights, and fleeting, uncritical modernism. Perhaps this is the only way to retain a culture that is slipping away—by emphasizing its most docile and easy-to-translate aspects, through repeated forms of affirmative action in which the paladins of nostalgia coincide with the traditional right wing of the exile community and a fair number of the island's organic intellectuals. So we end up with the Left repeating daily, faced with the crisis of the Revolution, what the Right used to repeat during its heyday: "It always used to be better than this."

Is it absolutely necessary to preserve a culture at such a price? Isn't overflow, troubled as it may be, preferable to the expropriation of paradoxes, contradictions, and antagonisms?

When a river breaks its banks and floods the surrounding area, the first thing that happens—as Roland Barthes recognized in *Mythologies*—is that the river disappears as it changes the contours of its surroundings. This breaking of banks is what is happening in both Cuba's literature and the literature of its diaspora today. And the fact is that writing and diaspora are two indivisible statutes: Diaspora opens up the possibility of inhab-

iting a world that was previously only read about. And vice versa: the world previously inhabited is now no more than writing, newspaper articles, websites, letters. In a word: text.

There is also the possibility that literature and diaspora become opposing forces because the difficulties of exile often leave you unable to write. It isn't long before reality kicks in, nothing like the journey home or what Maurice Blanchot observed in the *Odyssey*. That's when you have to stop being Homer and become the Odysseus you were always meant to be. You have to swap writing for sailing, for feigned deafness in the face of the sirens' song, and for the always patent (and pathetic) possibility of returning to a place that doesn't exist.

Cuban culture has, in its very foundations, a singular version of Odysseus: Matías Pérez. His vehicle was not a ship, however, but rather a hot-air balloon. His kingdom was not the sea but the air. (We might think this guy always secretly hoped to leave the planet entirely, because a raft, after all, is more than enough to get you off the island.) We know that this guy sold awnings, which in itself is a great metaphor: by leaving Cuba, Matías Pérez left Havana out in the open, exposed to the sun and the rain, especially given that we know his balloon was made of the same material as his awnings.

With the help of Antonio Vera-León's research skills, I can confirm that there are very few sources available on Matías Pérez. (One of them was the play by José Brene.) In contrast, there are hundreds of variations on *Espejo de paciencia* (Mirror of patience), the dubious founding text of Cuban literature. Matías Pérez is a kind of enigma. *Espejo* . . . a dogma. Cuban literature meticulously analyzed and canonized the text that addresses its foundation, however dubious it may be. (There is a strong likelihood that the poem was written almost two centuries after the date attributed to it, when discourse about the founding of the Nation became

important, and it seems likely that Domingo del Monte, a criollo proponent of the literary salon, was its main instigator.) Meanwhile, there is barely anything written about Matías Pérez, who did exist, and who had already completed two other balloon flights, according to contemporary newspapers.

Why?

Perhaps because Matías Pérez left the country and—an even greater sin—did not die for the homeland. He could not, therefore, be written into tradition, nor the anthem, nor the symbolic (and earthly) conglomerate of the Cuban nation. His absence was a specter looming over the image of the homeland, which people preferred not to think about. He was a paradox enveloped in silence, while a flood of prestige streamed over that tropical poem about palm trees and fruit—the precursor to tourist campaigns. It didn't matter that the hot-air balloon flight was one of the great moments of Cuba's incipient modernity. Because, all things considered, Paris was for Matías Pérez what it was for the poets José María Heredia and José Martí. And aerostatics, with their precursor, Godard, were for the island's first aeronaut what texts by Rimbaud, Verlaine, or Baudelaire were for modernist Cuban writers.

In a culture where the Nation, the Homeland, the Leader, and the Land become significant markers of identity, minority experiences are forced into real or metaphorical exile.

To the extent that, when someone leaves Cuba or quits their job, they are still said to have "flown like Matías Pérez." Meanwhile, equestrian statues of heroes of independence or the horse as a representation of masculine power in mythology, conceal a series of aerial and marine metaphors in order to discredit weakness, homosexuality, and even bilingualism: birds, sea bream, and wreckfish refer to forms that oppose the homeland's powerful legacy. These are prejudices, it should be said, to which even the playwright José Brene—who played an important role in

redeeming our antihero—was not immune. He suggested, casual as anything, that Matías Pérez was queer—a "flyer," like a bird, whom he suspected of simply passing through on his journey from being a fool to becoming a queen.

V

The West needs exoticism as a way of simplifying the complex cultures that lie beyond its shores. It even goes as far as refusing to recognize some of them as Western, as is the case with Cuba. That's why it rewards literature that reinvents bucolic landscapes ad nauseam, that is full of shades of neoconservatism, that is uncritical of its authoritarian tradition, and that unconsciously heralds the established powers. A literary balm for a bored West that will simultaneously extol the Amazon or the Costa Rican jungle and destroy it to build hotels, farm rubber, or film *Jurassic Park*.

One of the most influential artists on the contemporary scene is Félix González-Torres. A Cuban, born in Guáimaro, who grew up eating black beans and listening to Celia Cruz, though he was smart enough not to let that dictate his identity. His work is one of the most interesting and beautiful legacies of conceptual art, though he is practically unknown among Cubans or outside the art world. Besides, he is not what we might call a "writer."

However, his intense care with words, his way of accommodating the private within the public, his fine textual composition, the way he drops a story into an image—I have always considered these things to be a literary legacy.

González-Torres founded Group Material in New York and then developed a body of work in which he made no concessions to folklorism nor to multicultural opportunism. He understood Cuban identity as a gestural rite, a tide. He died of AIDS aged thirty-nine, leaving behind some pieces that might offer us a key to

what is meant by the art of inhabiting diaspora. One of them is a public billboard showing an unmade bed—a bed inhabited by the traces of its previous occupants. As though the bodies without backgrounds with which I began this essay might find their counterparts in bodiless backgrounds that today show us nothing more than an imprint. This is, perhaps, the secret of writing in diaspora, when neither home nor the possibility of return exists anymore: to grant a background to bodies that lack them and at the same time to find the lost bodies whose traces remain somewhere out there in the world.

THE REVOLUTION WILL NO LONGER BE FOR BIPEDS
2016

Long gone are the years when the Left lived for the Revolution and headed out, weapons in hand, into the jungle to conquer it. Long gone are the endless union strikes, the student protests capable of turning whole countries upside down, destabilizing governments, overthrowing tyrannies . . .

These days, after several springs, occupied squares, and "indignant tides," the New Left has found refuge in less rugged landscapes, which it is slowly getting used to and trying to transform. So it's not hard to find the Left sitting in parliaments and on the boards of directors of private companies, operating easily within a system that its antecedents used to revile, in times of blood and bullets.

To achieve all this, old concepts have inevitably been shaken up, from the family to the assimilation of globalization, via the recycling of radicalism in universities, politically correct language, the universal acceptance of the market, the shift from anticolonialism to postcolonialism, the abhorrence of any variant of the (physical) guillotine, or preference for Rousseau over Marx, implicit in the naturalism of some environmentalist or animal rights agendas.

So Sartre hated television? Today there are innumerable leftist critics or leaders fascinated by television series (mostly US ones, I should add). On the other hand, the way many political demands have been moved onto the internet has brought with it a new fetishism that confuses the straightforward buying and selling

of goods with the handing over of our data and which has established a virtual community as a substitute for *society*, a category that used to be at the core of any moderately serious left-wing project.

Is there any room for change on the horizon? Who will triumph in this new game of chess: the ability to change or the tactical string-pulling necessary to achieve it? It's a quagmire, this business of transforming the world via the very establishments designed specifically to keep it as it is.

Not that it's entirely impossible, but the political toll tends to be high. As an old teacher insisted to me in Havana, evoking Cuba's sovietization in the seventies, "The problem with ideological packages is that they always come sealed." (Let's just say they're not designed to make it easy for us to scrutinize the delivery.)

Let's think about the family. The struggle for gay marriage, the right to raise children in nontraditional ways, the role of the community or the state in education, new gender politics . . . All these battles have expanded the family rather than finishing it off; strengthened it, rather than blowing it to pieces. We cannot deny that the family has been wrested from the conservative monopoly, but it has also been pulled into the present as an indispensable societal nucleus.

The fact that the pursuit of social democratic goals is hailed as "revolutionary" these days is another symptom of an era in which anything can be granted that status. In recent years, we have seen Orange, "indignant," sexual, and digital revolutions. Back toward the end of the twentieth century, there was a Carnation Revolution in 1970s Portugal and—ten years later—a "conservative revolution" led by Reagan, Thatcher, and Chuck Norris. (Don't miss the documentary *Chuck Norris vs. Communism* by Ilinca Călugăreanu.)

In any case, the desire to change the world persists. Only, to

achieve this, we can no longer just resort to the bipedalism of our material past. That erect posture that makes us think of war and factories, of carrying the harvest and commanding the masses, of leadership and the avant-garde.

Most of what we used to call the historical subject—in the "ideological antiquity" written and filmed by Alexander Kluge—today responds, in most parts of the world, to different biomechanics. To the vital posture of a human who has exchanged the battlefield for the screen, the trenches for the armchair, the rifle for the remote control.

DEMOCRAT, POST-COMMUNIST, AND LEFT WING
2002

As soon as I define myself as a post-communist, people start getting prickly. I put the word on the cover back when I published *El mapa de sal* (The map of salt). But since people's irritation is growing, perhaps it's worth justifying the logic of this term I have liked using ever since I lived in Cuba.

After a decade in exile, of immersing myself eagerly in this place called the world, I find it impossible to separate my position on Cuba from my position on the world. My Cuban condition is just one chapter of my concerns: a very important chapter, but not the heart of the book.

I'm a bad patriot, you say? Well, yes, I've worked hard and diligently at that particular sport. You say my stance is ambiguous now? Ambiguity has always fascinated me, and I consider it a gift. (I know people who left the country in order to be ambiguous.) You say I'm not combative enough, and that this gives the Havana regime a chance to survive? Please, it's not me who is keeping that regime alive, but rather—among many other things both complex and superficial—the people who have been promising to bring it down for forty years but who have the most to gain from Castroism, including the many benefits of a political lobby in Washington and a monopoly over on-air discourse, whose stations and presenters would both struggle to survive a day after the fall of the Cuban regime.

On the other hand, I understand that a not insignificant portion of the Cuban population supports a government that I found

unbearable—the Atlantic now stretches between us. I also understand that I have no right to assume those who live in Cuba are an acephalous mass that does nothing but obey and keep its mouth shut. In any case, I would point old and new anti-Castro heroes alike toward everything I wrote and published *in* Cuba—the preposition "in" strikes me as not unimportant—and invite them to see how much my position has changed, and whether there is anything apologetic in those pieces.

These humble gestures don't make me a hero, but at least I can say them without the need to intone a mea culpa, hide my old publications, or jump on the converts' bandwagon.

What does it mean, then, to define myself as a post-communist? It's simple: it means using the critical energy employed in the old system to be critical once again, this time of the current apotheosis of capitalism and the cultural failure of liberal strategies in Eastern Europe. A warning: apologizing for what you previously questioned—whether a city, a social system, a moral stance, a religion, or a comandante—can only give rise to new dictatorships. Perhaps because authoritarianism takes ownership of everything of which we are uncritical.

In Eastern European countries (and in China too, where they still carry out executions that are practically medieval) the system of freedom and democracy has privileged consumers over citizens (therefore failing to meet people's expectations of the West—the very people who pulled down the walls and borders). The latest works of Robert D. Kaplan, Francis Fukuyama, and other prophets of neoliberalism are explicit on this point: democracy is not a sensible direction for certain countries—China, Peru, the former Yugoslavia, parts of Africa—because capital investments rely on the security they get from those places, where a heavy hand acts as an essential guarantor.

Henry Kissinger was ahead of the game with all this, and if

some forget that neoliberalism was first tested out in the Southern Cone in the form of fascism—torture, family lines shattered and reconstituted in horrifying ways, mass murder, assassinations, ultranationalism, concentration camps—that's their problem. Because all this brings about a serious dilemma for intellectuals: liberalism and democracy are no longer synonyms. Especially now that the mixture of Coca-Cola and Tiananmen has created a cocktail that will one day be known as Free China.

I also find it impossible to ignore the fact that Cuban anti-communism has a significant dose of McCarthyism, updated now by our old American friend Jesse Helms, an inveterate censor who, in the name of the Moral Majority, has thrown God knows how many apparently indecent artists under the bus: Robert Mapplethorpe, Andres Serrano, the Britart movement. We're talking about a man who promoted the Helms-Burton Act and the hundred million dollars of funding for Cuban dissidents, so it stings a little. Mainly because the Cuban artists and writers whom I admire and with whom I work—almost all of them in exile, many in Miami—meet the aesthetic and moral conditions to be branded by Senator Helms, or perhaps by someone like him who is anchored in the dominant culture of the fifties—those years of splendor in a republic some try to convince us is now an Eden of democracy and identity.

It wasn't just its McCarthyism—the Cuban right failed doubly, something for which, in a democracy, any community would hold its leaders accountable. First, it has not fulfilled its main goal and political promise: Fidel Castro is still active and in command. Second, it has a poor democratic record. Their promise of the future is adorned with a long list of nepotisms, authoritarian procedures, dismissals of those who do not share their ideological leanings, as well as language anchored in the Cold War. Seen in this light, being anti-communist and being democratic are not the

same thing either. In fact, eleven years after the fall of the Berlin Wall, the West is less democratic than before, and its repressions are more glaring for those willing to look further than the knot of their own ties.

In any case, my polemic is not aimed solely at conservatives or liberals, many of whom have shown respect for my ideas, which are contrary to their own. I'm mainly interested in aiming it squarely at the Left. On the one hand, at the Left that takes solace in academia and the curricular shuffling of the Cuban question around campuses outside the island. And on the other hand, at certain ideologues on the island who are now concerned only with getting their hands on some trip, some publication, in exchange for accusing other intellectuals—especially younger ones, lest they occupy the seats and pages so yearned for by these new guardians of revolutionary purity—with the added arrogance that comes from knowing they are protected if they do so.

This Left cannot deal with democracy in any of its forms, because it has never taken up Rosa Luxemburg's revolutionary maxim: "Freedom is always freedom for those who think differently." For these two versions of the Old Left, the fall of the Wall was their own downfall too. For a New Left—which understands democracy not as the ultimate goal of politics, but as ground zero for the direct involvement of civil society in political decision-making—the fall of the Wall is the best thing that could possibly have happened. Among other things, because it has marked a contemporary milestone that invalidates many of the refrains of 1968 and especially because it does away with the possibility of socialism being linked with the gulag again.

New generations—whether they are left wing or not—should take advantage of the range of possibilities that will open up in the wake of the current dismantling.

Democracy—from Plato to the present day—is more than an

abstraction. And the so-called New World Order has subtract-ed—a lot—from that fascinating and complicated experiment that is the coexistence of people who disagree.

Perhaps the moment has come for the Left to take back respon-sibility for dissipating the current concentration of power by broadening the democratic field based on society and its citizens. That alternative sends us directly to a debate about being *post-* (post-communist and post-liberal).

The alternative is to join the ranks of a pre-Berlin right, as anachronistic as its natural enemy, the Stalinist states.

This being the case, the arguments thrown at us have the ring of dead languages. Perhaps they are the echo of a silenced voice emerging from the black holes of the Cold War.

CUBA AS COLLATERAL EFFECT
2003

The Iraq War and the conflicts generated around it involve a confrontation between two ways of understanding the world and politics: those that derive from the Cold War and those able to adapt to new scenarios. So perhaps George W. Bush's insistence on depicting a bipolar world divided into Good and Bad blocs, or his way of tackling terrorism, really belong to the Cold War. Meanwhile, unique alliances like the one between France, Germany, China, and Russia, or antiwar demonstrations represent the opening up of other paths toward a new global politics.

In Cuba, a country that weathered the communist era under extraordinary circumstances and which today survives, in complicated ways, the fall of the empire that sustained it, there are echoes of the old politics as well as timid attempts to sketch different designs for future coexistence. So while the world was clamoring for the end of the Iraq War, US Congress was negotiating an easing of the embargo, and internal dissidence had reached previously unseen levels of international presence, the Cuban government's response of "immovable socialism," old-style US diplomacy, and the reactionary position of the Cuban far right in Miami (capable of marching in favor of the blockade and the Iraq War or "against the Varela Project!" belonging to internal dissidents) seemed like a retreat to the stone age of the Berlin Wall, returning the country to the extreme options of "Homeland or Death," "With Me or Against Me," "Intransigence or Dialogue."

On top of all this, there was a repressive crackdown resulting

in the imprisonment of eighty prisoners of conscience, staked out between the reckless immunity of US diplomacy and the absolute impunity of the Cuban regime. For those, like myself, who understand that dissidence against the Cuban government does not necessarily undermine hope of a progressive future, that in any new politics the Left and dictatorship cannot be synonymous, and that the commitment to democracy in Cuba cannot be jeopardized by military intervention from the United States, the recent imprisonments are, if possible, even more heartbreaking.

If a state with a concentration of power as absolute as Cuba's is not capable of tolerating eighty dissenting voices, this is not a sign of its strength, but rather of a worrying weakness that is hard to ignore.

NIETZSCHE'S CUBAN GLOVES

2004

Whether geographic or ideological, aesthetic or economic, reactionary or reformist, Cuba's communities are today governed by uncertainty. This sense of unease, exacerbated by the fall of the Communist Bloc and its subsequent impact on the island, is a formidable stimulus for essay writing. At least, that's how it has been understood by a new generation of Cuban essay writers, from every shore and of every stripe, who have burst onto the cultural scene and broadened the options available to them. They have injected life into themes such as national identity (Eliades Acosta Matos), the rethinking of the 1902–1959 Republic (Duanel Díaz Infante), hedonism (Antonio José Ponte), the imaginary construction of the city (Emma Álvarez-Tabío), the persistence of the Revolution beyond the physical disappearance of its original leaders (Manuel Henríquez Lagarde), the deconstruction of the Cuban canon (Rolando Sánchez Mejías), apostasy as a possibility for culture (Jorge Ferrer), Cuba's uniqueness in the global era (Enrique Ubieta), the way memory manipulates (Ernesto Hernández Busto), the performative condition (Glenda León), the role of the classics in Latin America (Rufo Caballero), and the influence of exile and cultural studies on island intellectuals (Víctor Fowler).

The work of Rafael Rojas, who has led the way on some of these themes and touched on almost all of them, has also given rise to the biggest controversies and has the greatest range, because it spans literary and academic essays, as well as articles in the popular press and political analysis.

It goes without saying that this group composes neither a political party nor a group of friends. These writers and others have been involved in heated arguments that have invigorated Cuban thought and recalibrated it for the twenty-first century. There has been slander and insults too, which will go down in the history of criollo political folklore. These controversies have played out on the island in magazines like *Casa de las Américas*, *La Gaceta de Cuba*, *Temas*, and *Contracorriente*. In exile, they have been published in *Apuntes Posmodernos* and *Encuentro*, by Editorial Colibrí, and in the online publication *La Habana Elegante*. *Criterio* magazine deserves a special mention, where for twenty-five years Desiderio Navarro has nurtured a good number of these thinkers as well as translating and publishing incredibly varied material on Marxist theory from all over the world.

Along with the historical fact of the fall of the Berlin Wall, the other great intellectual catalyst for this generation of writers has been the modernity-postmodernity debate. They have taken on Cuban masters—Cintio Vitier, Virgilio Piñera, José Lezama Lima, Che Guevara, Antonio Benítez-Rojo, Gustavo Peréz Firmat, and Fernando Martínez Heredia—as well as French post-structuralism, German critical theory, Anglo-Saxon neo-Marxism, Latin American revolutionary thought, the remnants of dependency theory, and US cultural studies.

Beyond reaffirming the Revolution or their dissidence, post–Cold War essayists are contemplating an era in which their most immediate interests will coexist with virtual reality, cloning, the conquest of Mars, the changing demographics of the planet, globalization, and terrorism. In that world, sacred terms like utopia, revolution, communism, solidarity, democracy, homeland, market, and freedom will be mercilessly rehashed.

Given the magnitude of the future already knocking at its door, the new Cuban essay would be wise to pay attention, just for a

moment, to Nietzsche's recommendation about ideals: you don't need to refute them, but it is worth handling them with gloves. Whether the gloves belong to a surgeon (willing to sink the scalpel into reality's deepest organs) or a boxer (taught to immediately floor any contender who thinks differently) will depend on each person's skills, on what they understand by culture, and on their preferred way of inhabiting that territory—the essay—founded, in the geography of literature, by Michel de Montaigne.

SPIELBERG IN HAVANA:
A MINORITY REPORT
2003

I

In the autumn of 2002, Steven Spielberg visited Havana. Despite the pope recently giving mass there, ex–US president Carter speaking about democracy, several US congresspeople complaining about the end of the embargo, Arnold Schwarzenegger smoking a cigar, the Baltimore Orioles playing baseball, Kevin Costner showing Fidel Castro his reimagining of the Missile Crisis, the establishment of the first market selling US products, and Sara Montiel getting married there ... Spielberg's was no regular visit. Given Cuban people's contagious enthusiasm, it was easy for the people organizing the US director's reception to flood cinemas with his films, both futuristic and fantastic, social and historical. It wasn't hard to pack the auditoriums with audiences who were used to bearing the unrepentant burden of history and society every day of their lives and were also keen fans of futurism and fantasy.

Havana suddenly became an alien, fantastical city: stalked by *Jaws*, moved by *ET*, crying at *The Color Purple*, inconsolable over *Schindler's List*, distressed by the slaves in *Amistad*. And to top it off, the premiere of *Minority Report*, whose key is anticipation. If Spielberg has it right, by 2054 criminals will be arrested before—not after—they commit their crimes. He depicts a post-democratic world where the presumption of innocence has given way to the certainty of guilt and where minority dissent is

eliminated in the name of unanimity. There is something about this film that can serve as a parable of Cuba's present and future.

According to trends and desires, the largest island in the West Indies can expect many different futures. They are lying in wait, and range from the future of "intransigent" socialism (as the regime that has governed the country since 1959 has once again decreed) to a liberal future committed to the free market, insertion into the global economy, and a multiparty system (a future to which liberal communities both inside and outside Cuba aspire); from a neoconservative future involving a political, moral, and cultural return to the fifties (found among the Cuban far right and in the Cuban American National Foundation, for instance) to a US future (a minor dream, for sure, of being annexed, thus locating Cuba in the custody of the United States, much like Puerto Rico); from a Latin American future (a poor future involving dependence on remittances from abroad, structural corruption, and continual crisis) to a Russian future (in which the country would go through what has come to be known as "shock therapy"—direct transition from socialism to the most savage capitalism, amid the chaos resulting from that explosive mixture of old nomenclature and new mafias). To all this, we might add proposals that swing between rupture and continuity (as much of Cuban social democracy, both among the internal opposition and the exile community, has argued; a position, moreover, that a fraction of the island's government is also suspected to hold). Meanwhile, a key faction of the dissident movement has taken advantage of loopholes in the socialist constitution—with the recent Varela Project as its masterstroke—and collected over eleven thousand signatures with the aim of reforming the system from within and later calling a referendum. Their main advocate, the Christian Democrat Oswaldo Payá Sardiñas, has been awarded the Sakharov Prize for Freedom of Thought by the European Parliament, and

has been nominated for a Nobel Peace Prize. Catholics—very active since the pope's visit—are quite literally basking in the glorious possibility of acting as a hinge between this regime and the next, and in the danger this would pose for the future laicism of the Cuban State.

II

Beyond Cuba's borders, Europe and the United States have their own models for puzzling out the island's future. While the European Community introduces itself as an alternative to the United States by trying on the one hand to encourage economic investment and on the other to punish Havana for its democratic shortcomings, much of the European Left still sympathizes with a government that, to some degree, turns the romantic arsenal of the Revolution, the challenge to imperialism, and more recently the anti-globalization movement, to their advantage. (Speaking of which, Fidel Castro himself presented the Cuban edition of Ignacio Ramonet's book *Fidel Castro: My Life, a Spoken Autobiography*.)

In the United States, for its part, there is an intense struggle between the pragmatists—Wall Street, farmers' unions, powerful political pressure groups, as well as progressives who calculate Cuba's future based on current investment opportunities there—and the hardliners—among them the ultraconservative Republican senator Jesse Helms, the Democrat Robert Torricelli, and the Cuban American lobby—who think the embargo should stay in place as an indispensable safeguard of the transition.

The embargo is undoubtedly the most uncomfortable of issues uniting or separating these groups. There is a wide variety of people—from the Cuban government to certain liberals—who think the embargo or blockade is unfair, not fit for purpose, or,

even worse, a way for the Cuban regime to justify the economic crisis, its limited ability to open up, and in particular its lack of support for fundamental changes to democracy and individual liberties. The Right and far right of the Cuban exile community tend to be in favor of the embargo, as do the more belligerent nuclei of the internal dissidence movement. These groups equate Cuba with apartheid South Africa, insisting on a Cold War ideology—they don't care that the United States has by now normalized relations with China and Vietnam, for example—and on an economic blockade even stricter than the current one in order to break up the Cuban government via a strategy advertised with the slogan "Turn the Hungry into the Angry."

Each one of these imagined futures is so precariously balanced that none of them, in and of itself, seems able to guarantee anything resembling stability. In any case, all these predictions seem pretty fanciful because, if the history of Cuba has taught us anything (even if it has not always been for the better), it's that surprise has always been an intrinsic part of the nation's historical development. Cuba stood out from other Hispanic American countries during the Wars of Independence, as the last colony (along with Puerto Rico and the Philippines) to gain independence from Spain. It stood out, too, during the Republic (1902–1958), a period marked by two dictatorships with a liberal bent and a progressive constitution sandwiched in between. It stood out during the revolutionary era, when it held itself apart from the Soviet Union, in the sixties, when Che Guevara mercilessly tore apart what he understood as Soviet colonialism, and in the perestroika of the eighties, when Cuban politics went in the opposite direction to Eastern Europe. And it stood out even more when the Communist Bloc collapsed and everyone's money was on the Cuban regime falling apart too—the socialist government was given no more than two years and there was a whole swathe

of books about Fidel Castro's final hour—but it managed to navigate those extremely choppy waters with skill.

As in *Minority Report*, in all these periods Cuba's future was designed in advance. And like in the film, which is set in the middle of this new century that's just recently got off on the wrong foot, it's possible the island will manage to evade all those futures and find some unforeseen escape route; perhaps its possibility lies in the unexpected, and the avatar governing its circumstances is not to be found among the sacred books laying out those ironclad futures that must be fulfilled. This might be for the best, seeing as all the futures, both official and unofficial, that have been offered, demanded, or condemned for this country are so committed to the present that their credibility is as dubious as the very reality they aim to preserve or transform.

In any case, the predictions keep coming. And in this age of genetics and increasing information and virtual reality, the oracles of the future of this country are becoming more and more persistent. In fact, we could say that in Cuban society today—in public and in private, in the square and at home, whether shouted or whispered—the only way to behave is with one eye on the future.

III

As the cards are laid out in this unique tarot reading, we have a serious warning for the doomsayers. Whether what's at stake is a future under the mandates of total capitalism—free market, multiparty elections, subjection to the dictates of the IMF, the imposition of bourgeois standards of moral and cultural existence—or some kind of social democracy—that complicated equation capable of mixing political sovereignty with individual liberties, social justice programs with private initiative, the Rev-

olution's achievements in education and health with stimuli for productive competition—what is certain is that none of these has a Hollywood-style red carpet waiting to welcome it. Especially because it's very likely that all these options will be forced to coexist. And coexistence is a word absent from the political dictionary of a country in which the ideological conflict has been dominated by an unhealthy, ruthless contempt for opposition and for dialogue itself. On the island and off it, on the Right and on the Left, Cuban politics has been governed by the furious extremes of "All or Nothing," "With Me or Against Me," "Intransigence or Dialogue," "Socialism or Death."

According to the liberal future predicted by, among others, Carlos Alberto Montaner, its most optimistic representative in politics and theory, the country will join other nations governed by parliamentary democracy, free elections, market economy, reduced public spending, and the dictates of the IMF and the global economy. For Montaner, these ingredients alone would clear the Cuban path to plenitude. Among the new generation, however, Rafael Rojas has advanced a more pessimistic liberalism. And while he agrees wholeheartedly that "any exit from the labyrinth of Cuban solitude implies communion with Western democracy," he still warns us of a tragic delay before the country's arrival at this future.

"Today Cuba is barely a post-communist nation. Tomorrow, it will be nothing but a democracy without a nation, a market without a republic."

Thus spoke Rojas.

To those who predict a Cuba according to liberal norms, there awaits a complicated situation. Leaving aside liberal fundamentalism as blind as the Marxist-Leninist orthodoxy it opposes, it is hard to ignore the fact that their practical and doctrinal presuppositions invite us into a world that is beginning to suffer

serious faults. So it will not be enough to push democracy in its present Western form, because Cuba won't get there until the system has undergone critical revision in every community, not just the left-wing ones. From Ulrich Beck to Francis Fukuyama, Robert D. Kaplan to Oskar Lafontaine, Anthony Giddens to Richard Rorty, that style of democracy is under suspicion, even more so if we look toward Latin America and the United States, to the region to which Cuba belongs. Nor should those who propose a liberal or neoliberal exit forget that the Berlin Wall and the Communist Empire collapsed onto both sides, and will also involve the decline—no less inevitable for being slow—of the liberal order as we know it today, in such a way that current democracy—which is to say, liberal democracy—will be a necessary but not sufficient condition for contemplating Cuba's future. On that note, a new generation socialist thinker in Havana, Víctor Fowler, has expressed this agonizing certainty: "I am convinced that the present voracious, transnational capitalism, beneath its mask of democracy, has even less to offer the Cuban people than the worn-out socialism we have today." And he doesn't hesitate to confirm the tragic dead end to which Cuba's long catalog of paradoxes will lead, because socialism, "as prisoner of its contradictions, does not know how to resolve them, while capitalism, true to itself, can only aggravate them."

There is another very important issue to do with a neoliberal exit that must be addressed. Despite the paternalism and the apotheosis of the gerontocracy haunting the Cuban problem— ageing leaders, the continual wheeling out of elderly musicians from the Buena Vista Social Club, veneration of forties and fifties automobile technology—there is a latent generational issue, no matter how you look at the future. And as much as it pains some people to admit it, it won't be the founders of the Revolution or of the exile community (almost all of whom are in their seven-

ties today) who will experience a changing Cuba. It will be young people. And it turns out that most Cubans were born and raised under the Revolution. However many changes can be glimpsed on Cuba's horizon, this majority intuits that in the future they will come under suspicion. That they might be considered marginally Latin American, marginally post-communist, marginally Western, marginally democratic, marginally capitalist. Either because they acquired some of these identifiers early—or because they will acquire others late.

So, just as it is a mistake to assume Cuba is nothing but the Revolution, it would also be a dire error to assume the island's future can be predicted based on the radical changes the Revolution implies, symbolically and routinely, culturally and sexually, in the family and in the body. This is because, among other things, the capital-*F* Future has long been the rhetorical, virtual, and real dwelling place of most Cubans alive today.

The issue is no less complicated for those who dream of a socialist future for Cuba amid the peculiarities of this global era. First, because it would be practically impossible for it not to pass through some version of democracy. And also, because to the Cuban government's repeated, unquestionable assertion that human rights comprise education, health, and freedom from hunger, it would be impossible not to add free elections, individual rights, the opportunity to return from exile, an end to persecution for political ideas, the dismantling of ideological censorship, and a long et cetera.

The socialist versions of the future will have to know other things: even if their power were to exceed the current regime or emerge from democratic elections, it's not feasible to imagine that they could govern unanimously, perhaps not even with a majority. They would have to endure options, rivals, opposing ideologies, pluralistic debate, diverse means of expression, hostile

media. They would even have to be prepared not to be in power, whether because the enemies of socialism have succeeded at the ballot box and defeated them legitimately, or because they managed to mount an international conspiracy and violently depose them. Sandinista Nicaragua—marred in part by the Contras' war of attrition and in part by corruption—is a good example of this first possibility: a revolution that loses power in a democratic game that the regime itself recognized and promoted. The coup against Salvador Allende's Unidad Popular party in Chile is an example of the second.

IV

Tourism, the opening up to the dollar and the euro, and a fledgling market economy have made Cuba a multifaceted country where socialism is beginning to coexist with capitalist zones. Within the range of possibilities offered by its economy, depending on how you look at it, the island appears either to be a sex paradise or communism's ultima Thule; the last bastion of anti-imperialism or just another tourist destination.

The world of pre-revolutionary Cuba—vintage cars, a return of early son cubano, gerontocracy as truth-bearer tells us that Cuba today is already experiencing a return to the past. And also that this past can be mixed with the order that emerges from the Revolution. It can be contained, a bubble keeping the socialist program going in certain fundamental areas. The question is: For how long?

At the end of *Minority Report* there is someone who disagrees with the official line, who possesses the secret of surprise, the gift of anomaly, the minority voice breaking with the oppressing majority. Perhaps a stealthy, anonymous character is walking along the Paseo del Prado in Havana with the keys to the country

in their worn pocket. Perhaps this arcane figure is the sign of a highly democratic exercise. Because it won't be about choosing a president or a way of being governed anymore. It's about choosing a future that contains all those choices at the same time.

TURNING RHAPSODY
INTO RAP
2005

I

During the first three months of 1960, Jean-Paul Sartre toured Cuba. Early one morning, accompanied by Simone de Beauvoir, he made a rather mysterious visit to the office of a high-ranking official in the new revolutionary regime, the Minister of Industries. Breaking protocol, "the Revolution's best soldier" received them in the office "that never slept."

"It was Guevara," Sartre wrote.

Photographs of that meeting have gone down in history.

The two men facing each other. Che in his armchair. Sartre on the sofa, one eye on de Beauvoir, the other on the Argentine comandante.

The young revolutionary: beard, mane, military boots, beret; the shadow of insomnia. And the older, organic intellectual: suit, cigar, glasses; quite literally, at the guerrilla's feet.

Che was known for his irony and an acid, sardonic sense of humor. The photo shows him rather distant—amusingly distant, you might say. Sartre is almost genuflecting.

For some reason, Che did not play the role of tour guide for the French philosopher. Unlike Fidel Castro, he was aloof, and in Sartre's memoirs there is nothing to indicate that being a good host figured among the things keeping Guevara up at night.

This did not get in the way of intense conversation, however, nor, of course, of courtesy. There is photographic evidence of this

too. At some point in the conversation, Sartre lit up a Havana cigar and Che held out an old compact leather-bound lighter for him. Then, in the middle of that room, a flame was lit. The Prometheus who will steal fire. Owner of the torch of the future, the bonfire that will burn time. To be offered a light by Che Guevara in person: the synthesis of all revolutionary fantasies.

The saga that began with that gesture is still ongoing. Like a relay race, the revolutionary fantasy Sartre founded has passed from hand to hand, down hundreds of athletes on the Western Left who have visited Cuba in pursuit of their own personal utopia.

What happened was so much more than the lighting of a cigar. Seen in the light of political history, Sartre's cigar was not a cigar, just as in the light of art history Magritte's pipe was not a pipe.

Since that first flame, a considerable troop of philosophers, musicians, novelists, poets, cinematographers, and even theologians have made the Caribbean island the object of their revolutionary fantasies, the incarnation of their redemptive dream, or the ideal therapy allowing them to locate their discomfort with the malaise of Western culture somewhere else, somewhere picturesque and far away. Not the Bolshevik Revolution, which so excited John Reed, nor revolutionary Mexico, which so fascinated André Breton and Leon Trotsky, nor Comrade Mao's China, depicted by Andy Warhol and John Lennon, inspired such passion for so long.

In his foundational book, *Ouragan sur le sucre* (Storm over sugarcane), Sartre himself claimed to have found (finally!) the coming of a revolution without ideology. Young Régis Debray's *Revolution in the Revolution?* proposes the foco theory of revolution by guerrilla warfare as a panacea—the possibility of a non-Stalinist global revolution. In *Cuba*, the film by Richard Lester (who also directed the Beatles in *A Hard Day's Night* and

Help!), the superspy Robert Dapes, played by Sean Connery, very quickly comes to question his mission to kill Fidel Castro deep in the Sierra Maestra after he has to confront the tangling of an inevitable love affair and the by now obvious failure of Batista's tyranny.

Something similar happens in *Havana* by Sydney Pollack, where a mature Robert Redford finally hurls himself into the revolutionary fray in a torrid mix of gambling, orgies of highly available Cuban women, and the seduction of the film's beautiful heroine (Lena Olin). The resounding success of the Buena Vista Social Club under the aegis of Ry Cooder is no secret, but Santiago Auserón and David Byrne had previously explored the roots of Cuban music with a clearer contemporary perspective and a more comprehensive intellectual register.

Unlike the imaginary islands and cities of Thomas More, Francis Bacon, Tommaso Campanella, and Erasmus, for the intellectual left Cuba was a far-off but real island, an exotic yet Western wilderness with an authoritarian yet charismatic leader, much like King Utopus, founder of the darkly perfect world that was Utopia.

II

The Left's Cuban obsession perhaps needs an explanation that's more psychological than political, more erotic than ideological, more personal than social. Only full-blown psychoanalysis can help us understand another interesting peculiarity: the prudishness of these intellectuals when it comes to talking about their other passions; perhaps due to the unconscious application of Sartre's dictum "hell is other people." Maybe that's why Cuba has not had its own version of Mexico's *Under the Volcano*: Malcolm Lowry had the honesty (not to mention the immense talent) to

talk first and foremost of his own destruction, his own inevitable ruin. He was his own hell.

In the masterpieces of the Revolution's red rhapsody, four characteristics are repeated almost constantly: confirmation, speed, distance, and discrimination.

Confirmation of a revolution that triumphed where others have failed. (Manuel Vázquez Montalbán liked to say that the Cuban Revolution was the revolution his generation had not been able to achieve.)

Speed, because of the short time invested in making rules and speaking on behalf of complex processes, carried out quickly and urgently in a matter of weeks or days. (Sartre is one of those who spent longest on the island—just over a month—to write his book about the Revolution.)

Distance, so they can ensure the safety of their revolutionary passion in some unequal but permissive Western democracy. (After all, there has always been a safe home—a whole ocean away, just in case—where the defense of the Revolution can be continued from afar, despite capitalism raging all around.)

Discrimination, because of the invariably secondary role given to Cuban voices, which have almost always been used as mere extras. (As though natives were destined to provide experiences, while First World intellectuals provide the ideas; Cubans for flavor, the First World for wisdom.)

Fidel Castro has been reading Machiavelli since a very young age. So he has always known that a revolution—principally his own—is not necessarily improved by having more and more European and US intellectuals affiliated to the cause, just as a profusion of regrets and changes of heart (proportional to its number of backers) does not necessarily make it any worse. Rather, what is useful is if those intellectuals have reputations in a range of different media, an appetite for mischief so they rise to the challenge

of sleeping with the enemy, and a desire to call out the unjust world of liberal democracies while present in the territory of their harshest and most long-standing critic. So Sartre steps away in 1971 because of the famous "Padilla affair"? Saramago can take his place. Saramago distances himself briefly in 2003 because of the "Rivero affair"? Oliver Stone is right there to pick up the torch.

III

This excess of fascination with and works about revolutionary Cuba involves more than just a troubled island and its no less troubled inhabitants, who are the real heroes and victims of the Revolution, even if intellectuals prefer to privilege the comandantes, ministers, and famous colleagues in their panegyrics. For many of these intellectuals who sing of their revolution, Cuba is not just Cuba, it's something more—like Sartre's cigar, or Magritte's pipe. For them, the Cuban Revolution is, for example, an excuse to criticize a world organized according to the market and, by extension, the evils of capitalism (which amount to all of capitalism). In a world where democracy has become a perfect machine for constantly saying "no" in the name of consensus, Cubans, according to many of these works, could well be spared the tortuous path through it. This contempt for formal democracy no longer belongs exclusively to the Left. The West is forcibly stepping away from this model thanks to its growing divorce from the market.

Mind, though: fantasy is not meant here in a pejorative sense, "as mere appearance or deceitful image." Following Peter Sloterdijk, I prefer to approach it "in the sense of a productive theory of the imagination, as a demiurgic mania, as an idea that brings itself to life, as an operative fiction."

In this area, it's impossible to avoid making the connection with Freud and a 1907 conference titled "Literature and Fantasy,"

in which he examined Jensen's brief novel *Gradiva* in detail. In his talk, the founder of psychoanalysis compares the writer to a child playing make believe: they both create fantastical worlds which they end up taking seriously. I should add, too, that there are many left-wing intellectuals *not* taken in by the mirage, who have behaved, almost secretly, according to a different logic, in order to extricate their Cuban colleagues from the effects of various injustices. Juan Goytisolo supported Reinaldo Arenas, and, as many will know, while in Paris, Julio Cortázar helped José Lezama Lima publish *Paradiso*, a controversial novel that came out just before the poet's final years, during which he lapsed into literary silence. In any case, these are not the focus of the problem posed by this essay, which is concerned with the utopian discourse emanating from the Cuban Revolution, where fantasy, naïveté, and hope come together to create a mythology.

IV

While the utopians gave detailed descriptions of a better life in far-off cities, these other authors have little to say about daily life in Cuba, being instead principally interested in critiquing the Cuban model. Very few of them describe in any detail those who have grown up under the sun of this Caribbean utopia. And the reason is simple: most of those who rhapsodize about that life have not experienced it firsthand. For them, it is enough that they know about capitalism.

As with the orientalism scrutinized by Edward Said, Cuba has been useful in that it has allowed Europe (and the West in general) to define itself "as its contrasting image, idea, personality, experience."

And besides, it is not advisable to go through reality seeking to confirm what we have learned from books.

"To apply what one learns out of a book literally to reality is to risk folly or ruin. One would no more think of using Amadís of Gaul to understand sixteenth-century (or present-day) Spain than one would use the Bible to understand, say, the House of Commons."

Thus spoke Said.

And yet, my approach to these versions of Cubanism involves four different and, at the same time, complementary imperatives.

First: to read these fantasies about the Cuban Revolution as a chapter in the critique of capitalism and imperialism; a tiny island in the structure of the West's revolutionary imaginary.

Second (more problematic, perhaps): to perceive these works, in the period of the Revolution, as an intrinsic part of Cuban culture, just like the German naturalist Alexander von Humboldt at the end of the eighteenth century, or the Spanish philosopher María Zambrano in the mid-twentieth. In this I am merely following in the footsteps of José Lezama Lima, who believed the journal written by Christopher Columbus—despite its author not having a passport—to be Cuba's first poetic text.

Third: to understand these intellectuals' works as a unique territory in the history of neocolonialism. In this, I'm building not only on Edward Said's *Orientalism* and his study of Conrad and the Congo, but also on Che Guevara himself: his speech delivered in Algiers in which he fiercely criticized the communist camp, Stalinism (by extension), and many Western intellectuals who did not fully understand the trajectories of Third World countries but who did not think twice about declaring themselves spokespeople for them. Left-wing neocolonialism? Definitely. And the fact of it coming from the Left is an aggravating factor, not a mitigating one, when it comes to assessing this cultural behavior.

Fourth: to raise this debate on the Left, although I know some titans of the Revolution will reject my leftist affiliation based on

my presence here, in this country, which has allowed many people to mete out punishments and excommunications (or indeed to jump ship when things started to go pear-shaped; the list is long).

The Western Left's suspicion of critics from communist states has been a long-standing and unproductive cliché. Although many of us share in a critique of capitalism, our differences arise when it comes to the depiction of paradise. Those of us from "over there" do not bring back the same good news propagated by revolutionary tourism after two weeks of immersion across the water.

My stance toward intellectuals who have pursued their fantasy in Cuba is not, a priori, either critical or laudatory, though it is inspired by a growing irritation. In recent years we have witnessed cultural behavior that is worryingly reactionary. It goes like this: the initial enthusiasm of the sixties for the transformative and futuristic nature of the Revolution has given way, now, to an insufferable fascination with the pre-revolutionary world that persists or has been reborn under the Cuban regime. Hence the ecstasy over American cars from the fifties and sixties, the revival of rural motifs over urban ones, of old people over young, the past over the future . . .

Slowly, such fantasies become part of the tourist offering and begin to weave a service culture that appears to take us back not to *Ouragan sur le sucre* (Storm over sugarcane) this time but to *Our Man in Havana* (Graham Greene's novel or Carol Reed's film), a detective story in which the Revolution is barely present in the background and Cuban people, maracas in hand, are willing to do anything to earn a couple of dollars.

Even Oliver Stone's fascination with the figure of Fidel Castro is betrayed in *Comandante* by the abyss between the leader's moves and the accompanying soundtrack. In addition to the bucolic paintings on the walls of his office—a natural landscape by Tomás Sánchez, a baroque landscape by René Portocarrero, a

naïve view of the Cuban countryside—the whole soundtrack is pre-Revolution: the Trio Matamoros, Rita Montaner, Celia Cruz, and La Sonora Matancera . . .

There's no nueva trova, no Cuban rock, none of the fierce timba of the new salseros.

Nor, of course, do we find any of the acid arguments from the latest rap songs about the contradictions of present-day Cuba.

We can sense, then, that the members of the claque have opted for neutrality, leaving aside the more popular and contradictory characteristics of a rhapsody. This leaves them with unmitigated praise, which is neither practical nor useful, nor even left wing. The truly revolutionary thing would perhaps have been to transform rhapsody into rap.

THE LONG BRAND
2001–2007

I

"It's time for another revolution!" says Che Guevara.

He doesn't say it, though, on that initiation trip through Latin America that Hollywood turned into *The Motorcycle Diaries*. Nor does this conviction come after his achievements in the Sierra Maestra. It's not something he says in the Congo ("The story of a failure," he admits in the diary he wrote during his African adventure). It isn't even a desperate, final epilogue after he senses defeat in Bolivia.

Nothing of the sort.

The phrase is pronounced in an idyllic country house in the twenty-first century. It's not the high point of a political speech, though it might sound like it, but rather the conclusion to a series of scenes. They go like this: Fidel Castro walks toward the house and, right there in the doorway, is passed by Chairman Mao, who greets him and continues on his way. Castro crosses the threshold and meets Lenin, absorbed in work at his typewriter. He continues, and now it's Gandhi who looks at him from the bed where he is lying, and then Rosa Luxemburg and Martin Luther King who are happily playing foosball. Fidel keeps walking and now he can see, at the end of the corridor, long hair falling down the backs of two men, one older, one younger. Fidel reaches them. They are Karl Marx and Che Guevara. The latter turns to him, something dawning on his face, and says: "It's time for another revolution!"

115

Then there is the visionary moment when he turns his gaze toward a Dacia, showing the price of the car, and the advertising spot comes to an end.

Marx, Lenin, Mao, Luxemburg, Gandhi, Luther King, Che Guevara, Castro . . .

All of them advertising strategies. All of them made part of the capitalism they fiercely opposed, turned into a means of selling a product.

There is nothing new in this.

Just think of Marx and art. The man who wrote *Capital* has been humanized by the Cuban artist Lázaro Saavedra, who tore a piece of the philosopher's face off, revealing a carnality that communism lacked.

The Venezuelan artist José Antonio Hernández-Díez, on the other hand, had already sensed the commercial drift approaching the founder of socialism, so he built a pile of sneakers that spelled out the word "Marx."

In the advert for *Rock 'n' Roll*, Tom Stoppard's play directed by Àlex Rigola, Marx is shown with his tongue sticking out like the Rolling Stones logo. In Laboral, the center for art and technology in Gijón, they even opened a shop whose name was clear as day: Marx. And of course, we already know that the Beatles put him on the cover of *Sgt. Pepper* and that, since then (1967), we have heard version upon version of the joke about being a Marxist of the Groucho variety.

In a sense, there's no harm in this lighthearted handling of the founder of communism. Because in many ways, art after the fall of the Communist Empire has functioned as the continuation of the Revolution by other means.

II

Let's turn to that other icon of the Revolution, whom Fidel Castro encountered at the end of his road to the Dacia: Che Guevara.

His photograph, taken in Havana in 1960 and disseminated in 1968, a year after his death, is one of the landmarks of modern iconography, perhaps the most famous photo of the twentieth century. The guerrilla's face was captured by the Cuban photographer Alberto Korda at a mass event—an expression of grief after the attack on *La Coubre*, to which Sartre was witness—but circulated by the publisher and radical leftist activist Giangiacomo Feltrinelli, who cropped the photo and turned it into a poster. Feltrinelli spread it all around the world until, after a long and tempestuous lawsuit, Korda managed to get the rights back.

It was perhaps that photo that led Latin America into the age of the image. That depiction of Che represents a visual boundary between modern and postmodern uses of his image. He began as the face of the Revolution, but ended up being applauded far beyond it, when that Revolution was no longer a definitive goal on the horizon.

Che made his Long March through Latin America and then, after he was interrupted, he became the Long Mark of the Revolution instead: its enduring brand. Even to his bitterest enemies, that face remains a mystery, seeming to have a life of its own, a Dorian Gray of rebellions, an inevitable presence at every uprising. Wherever you go, it's impossible to escape that face with its halo of eternity.

Che is always looking at us. From a T-shirt or a designer cigarette lighter in a shop in Charlottenburg in West Berlin. From a beer named after him in London or gazing into the distance in an Amsterdam coffee shop . . .

If Che's became *the* face—even more so than Andy Warhol's

Marilyn or Mao—it's because, beyond his photogenic nature, he fulfilled modern iconography's own rituals: both symbolic and commercial, with both historical and exchange value. And besides, there is a distancing in that image; it appears outside time and space, disembodied. It has the sterility of a saint but also the essential appeal of modern fetishes.

In any case, it was not a conciliatory image. In fact, it opened up a perspective on the culture of violence that has been present to this day in representations of Latin America. Korda's Che spoke of a binary America, hopelessly divided between emancipation and domination, the Latin Americanism of Bolívar and the Pan-Americanism of the Monroe Doctrine, between the territory south of the Rio Grande and the United States. It was a total image of the ongoing battle between dependence and independence, between repeated strategies of domination and the consequent liberation movements.

As symbol and synthesis, this face was also pasted on the side of a bridge. Just like Giordano Bruno's burning body, which was planted like a torch between the Middle Ages and the Renaissance, this was a cultural product that straddled the modern utopia of a world that could not exist and the postmodern reality of a world that, because it is unbearable, we have had no choice but to aestheticize.

Like the Caliban so often re-created by Caribbean writers (Roberto Fernández Retamar in Spanish, Aimé Césaire in French, Kamau Brathwaite in English) Che's image seemed to depict Latin American culture as an agonizing contradiction, somewhere between pragmatic Prospero—the United States—and spiritual Ariel, who reflects high European culture. A Caliban deep in the task of conquering time and pinning Latin America's hopes on what was then still a futuristic and far-off twenty-first century.

III

In the year 2000 itself, the founding year of the twenty-first century, Brazilian photographer Vik Muniz appropriated the famous image of Che Guevara in a curious way. He spread tins of beans onto a blank surface and gave them the exact same shape as Korda's photo (face, beret, long hair, beard). Only then, once he had this "new Che," did Vik Muniz take his photo.

Between Che Guevara's first face—awaiting sainthood and veneration—and the new face created by Vik Muniz, Latin America has changed not only its image but also its cartography; principally, it must now be read according to different coordinates. Like a malevolent inversion of the end of history, it now turns out that some thirty million Latinos have invaded enemy territory from "below," while "up above," phenomena like the North American Free Trade Agreement have been responsible, for better or for worse, for breaking down the border between the two Americas. What the guerrillas failed to achieve militarily in the sixties is happening culturally in the new millennium, with Latinos becoming the Empire's second minority.

Vik Muniz's Che is the face of the dissemination of Latin American experiences, of the many guerrillas and armies, controlled territories and out-of-control states, of the boat people and wetbacks flooding the United States, of people who traffic weapons not for the Revolution anymore but for drug cartels and paramilitaries, and to wreak chaos in order to repress. It is the face of telenovelas as a form of identity and "interiority design," of the many ways of understanding the future and of the past that refuses to inhabit it. It is the face of the everyday mythology of communities who seem to be reminding their heroes, from the altar of the utopias in which they are petrified, that for the time being no project is possible unless it first passes through the reality of beans.

It's no coincidence, then, that Luiz Inácio Lula da Silva, a Brazilian like Vik Muniz, began his project out of hunger. There is a lesson to be learned here for those who have a liberal perspective on human rights, just as the assumption of power following elections is a lesson for the old Latin American revolutionaries who scorned democracy's formal politics. Lula has postponed any utopia obsessed with taking the country from zero to infinity when it is facing an urgent fight to reduce hunger from infinity to zero.

Muniz's Che has abandoned the radical dualism of the sixties and, incidentally, the psychology Nelly Richard once described as "complex periphery syndrome." That's why he has the insolent self-perception for which Aníbal Quijano once reprimanded Latin Americans: it's necessary to see "ourselves from a new point of view whose perspective can reconstitute our ambiguous relationship to our own history in a new way. A way of ceasing to be what we have never been."

Vik Muniz's Che takes up Caliban's old call again but manages to activate it in a different way, in the self-proclaimed crisis of the West (that Prospero disillusioned with himself). In this sense, it can be read as a critique of the arsenal of exoticisms and clichés with which Latin American culture is often served up today, so typical of the voracity for its own margins from which Western culture regularly suffers. If in the sixties the future appeared to the revolutionary culture of that time as the only possible folklore, now folklore has become the only possible future.

Fortunately, as in Guevara's own strategy of creating "two, three, many Vietnams," today we have two, three, many Americas, whose destinies have much more to do with the fervor of a club in Spanish Harlem than with the Organization of American States (OAS), much more to do with telenovelas than with idyllic novels by writers who once had the dubious privilege of having founded a subgenre like the "dictator novel."

Overpopulated with tragedies and heroes, plundered by a power that has functioned as the wailing wall of their corrupt and authoritarian policies, facing the failure of their conservative, socialist, liberal, and neofascist experiments, the Latin America depicted in Muniz's image has left its heroes busy building a utopia while its people devote themselves to the no less heroic work of putting beans on the table each day.

Twenty-first-century Latin America has decided to make beans the very face of its dreams. Unable to invade time (the future), it has decided to invade space (particularly to the north).

Korda's photo depicts a distant Che, already canonized, while Muniz's photo expresses, through its own paradox, something even more human. Che's first face dictated, held forth, gave orders. Che's second face matters not because of what he can tell us, but for his capacity to listen to the things twenty-first-century Latin Americans have to say to him.

A SEQUEL TO '68

2004–2008

I

If nothing else, in 1968 a triangle is sketched. Plots swing between Paris, Prague, and Mexico, loaded with the current pressing themes: Cold War, revolution, student uprising, decolonization, anarchy, *Tricontinental*, the death of Duchamp, free love, and slogans . . .

Lots of slogans.

Among the origins of those versions of '68, we can usually find the Cuban Revolution. That explosion in 1959 that, as a Patrick McGrath character senses, "turned cynics into romantics and romantics into fanatics." It was like a boomerang, with an encouraging outbound journey—a political project on the margins of the blocs, long hair, necklaces, a premonition of pop—and a less romantic return. On the island, 1968 was the Year of the Heroic Guerrilla (in homage to Che, who died a few months before the French unrest, Feltrinelli's poster version of Korda's photo, the Soviet invasion of Prague, the San Francisco strikes, and the massacre at Tlatelolco).

So grief and sacrifice were floating in the island's atmosphere. What had been sketched as an international revolution (or at least a Third World or Latin American one) was on the way to being "localized." What had seemed like an original experiment was on the way to becoming sovietized. What diversity there had been at the beginning was heading mercilessly toward uniformity . . .

In 1968 the transition from revolution to socialist state was completed.

That year, *Fuera del juego* (*Sent Off the Field*), the collection of poems by Heberto Padilla that gave rise to the "Padilla affair," was awarded a prize.

For Cuba, 1968 also brought a cinematographic milestone: *Memorias del subdesarrollo* (*Memories of Underdevelopment*). Tomás Gutiérrez Alea's film functioned, in its moment, as an aesthetic plea infused with dependency theory and Italian neo-realism; with Buñuel and the culture of poverty. It was a staging of middle-class Marxist theory and at the same time an epic tale of beings outside time and space. The tragedy of subjects who hate the past to which revolutionary dogma returns them, who live in the limbo of a present where there is no place for them, and harbor the illusion of forming part of a future that is no longer waiting for them. *Memorias* was an adaptation, and in some senses the pulverization, of a novel; a fleeting victory of the visual image over the written one in a culture saturated by words.

II

Based on the eponymous novel by Edmundo Desnoes, *Memorias del subdesarrollo* is the only Cuban film that has given rise to sequels. (I'm not entirely sure whether *Cercanía* [Proximity], by Rolando Díaz, counts as a sequel to Jesús Díaz's *Lejanía* [Distance] and *55 hermanos*, though I'll leave the thought here for others to ponder.) The point is that, in addition to Stan Douglas's *Inconsolable Memories* (2005), we also have a second part, shot by Miguel Coyula and written by Desnoes himself—this time titled *Memorias del desarrollo* (*Memories of Development*), about his life in New York—in which the author returns to his character and his own history after forty years.

Why make a ritornello out of this film? Perhaps the simplest answer is that it is the most emblematic film in Cuban cinema, though there is a problem with this explanation: such a status could just as well have caused the opposite reaction, meaning no creator would go near Gutiérrez Alea's film due to the "anxiety of influence."

There must be another answer.

For a country in perpetual transition, tormented by inconclusive or abandoned experiments in the name of a greater, almost mythological project, the main character—the hesitant Sergio—has traits that are adaptable to different eras and situations. The tension between such excessive social drive and such insignificant individual support condemns all possible "Sergios" to the agonizing experience of having to live on the edge.

Whether in the enthusiastic sixties, the dogmatic seventies, the eighties characterized by the Mariel boatlift and the subsequent opening up, the nineties when the Communist Empire fell and the dollar appeared, or even in the first decade of the millennium when an extraterritorial Cuba proliferated on the internet and in the blogosphere.

Each of these decades has a way of showing us that *Memorias del subdesarrollo* has no sell-by date.

In the original film, Sergio is an architect and enemy of the Revolution, whose family has left for the United States. But he prefers to stay on as a spectator because, after all, the Revolution hasn't just overthrown Batista, faced off US imperialism, and led the Latin American rebellion. In his case, it has also freed him from an unbearable, hypocritical middle-class Cuban family.

However, Sergio does not manage to integrate, not entirely, and he begins to slide toward inevitable self-destruction.

Like a little tropical Sade—minuscule in his anonymity, in the minor order of his transgressions—he has no place in either the

old Regime or the Revolution, as though the only options on his horizon were the Bastille, Exile, or the Guillotine.

III

Not even in his photographs of Cuba, nor in his version of *Memorias*, does Stan Douglas allow himself to fall into the stereotypes that haunt picturesque versions of Cuba by so many Western artists. Hence, no doubt, the positive reception it received from two Cuban critics. Dayamick Cisneros considers it "subversive," "sharp," "refined," capable of living up to Gutiérrez Alea's original version as well as altering it without betraying it. Carlos Espinosa is also full of praise, drawing attention to the intelligent inclusion of the spectator in the plot, and arguing that Douglas's piece should not be seen, under any circumstances, as a remake of the original film.

So there was Douglas, an artist from Vancouver, born in 1960, who had already taken on Proust and Orson Welles, Herman Melville, and Karl Marx, taking a risk in 2005 with *Memorias del subdesarrollo*, considered by many to be the most important piece of Cuban cinematography.

"This Revolution is against people like you."

These words, directed at Sergio, are uttered by a policeman. A tragic phrase from the romantic era. A logical phrase, given the class struggle waged by the Revolution in its early days. Sartre talking through the voice of the policeman? Probably. It's enough to remember the protagonist's repeated back-and-forths over the role of intellectuals in society and what they should prioritize according to their ideological commitment.

In *Inconsolable Memories*, that phrase is repeated, by another policeman, to Stan Douglas's protagonist—also called Sergio, also an architect. But unlike the original Sergio, Douglas's is black

and from a humble background, whose opportunities for social progression lie not in a bourgeois past but in a socialist future. The same phrase, in a different place, a different era, and a different class context, generates considerable dissonance. And our discomfort grows as we immerse ourselves in a three-dimensional work—a piece of cinema made for a gallery, not a cinema screen—that practically demands we participate.

Douglas's plot situates the arrest of the young architect around 1979. This means Sergio is, so to speak, a pre-Marielito, who may soon be labeled "scum" once the spring of 1980 arrives, when some 125,000 Cubans will be expelled from the country. But the causes of the Mariel boatlift (named after the port west of Havana through which that escape route opened) are not limited, however, to this specific label. They were much more diverse and deeply embedded in the complex web of the Cold War, stretched over the period between the Islamic Revolution in Iran and the Sandinista Revolution in Nicaragua, between the Cuban project's Stalinist drift and President Carter's political myopia, between the emergence of a marginality not resolved by the Cuban state and Fidel Castro's strategic skill in opening an escape valve for his own regime.

These tensions weigh heavily on the protagonist of *Inconsolable Memories*. A character we can locate in the Mariel Generation: very battered, very radical, very extremist, and very creative. It's easy to imagine Douglas's Sergio as a partner in crime for Reinaldo Arenas, Carlos Victoria, or Guillermo Rosales. A guy who was, like them, out of place. Without the classical halo of the masters who made their careers before the Revolution—Alejo Carpentier, Virgilio Piñera, José Lezama Lima—and without the postmodern glamor of the later eighties generation. An outsider oscillating between the communist government that branded them scum and tossed them out of the country because they

didn't fit into its perfect future and a traditional exile community that was never going to accept them entirely, because they didn't fit into their fantasies of a perfect past.

When you think of this non-place between two worlds, two eras, two politics, two generations, a not entirely objective idea comes to mind: Although the ideal protagonist of *Inconsolable Memories* should be someone from the Mariel Generation, its ideal spectator is perhaps to be found in the later generation, the generation of the sixties' demographic boom, the generation programmed to become the New Man of the Revolution. Someone who is still in time to dampen the incendiary profile of that rhetoric that insists on stratifying us into the People, the Cause, the Homeland, Democracy, the Perfect Future. Someone who can still conceive of an individual project and note that there is no memory for which there is consolation. That the only future that deserves hope is one that, like the past proposed by Stan Douglas, is imperfect.

THE MORENOS' SONG
2005

I

This time it's not a Trabant but a Cadillac . . .

A luxurious relic of the fifties (although the scene takes us back to the end of the twentieth century). And in it we have Wim Wenders as chauffer to Compay Segundo, the ninety-year-old Cuban trova musician whose real name is Francisco Repilado. Wenders is driving, dressed in a straw hat, while Compay Segundo sits comfortably in the back seat. An image very similar to the one of Eric Clapton and B. B. King on the cover of their joint album *Riding with the King*.

The tropics have a softening effect. On even the most rigid of artists. Wenders, for example.

The German filmmaker has gone to Cuba in search of a secret story. In order to find it, he glides through Havana, especially the Marianao neighborhood, looking for the Buena Vista Social Club.

Unlike in his film *The Soul of a Man*, in which he goes looking for three pioneers of soul who are lost, like Skylab, in the infinite night of the cosmos, in *Buena Vista Social Club* you can tell Wenders is rattled by what's going on in the Caribbean by the way he tenderizes everything. The island's circumstances permeate everything, and the city's poverty (although very creative) is almost absolute. In his foreword to a book published about the film, Wenders claims: "I had never been to Havana before." A line further down he goes on: He had "never shot a documentary film, not even a concert, and

certainly never fully digital ..." He also recognizes that he was not prepared for "what we were up to," although he considers that lack of knowledge to be "a good thing."

The first time Wim Wenders hears "Chan Chan" and "Dos gardenias" is, of course, in his car. Ry Cooder had given him the recording and he found it "comforting like a hot bath" and "refreshing like a cold shower."

Like "Tibio" Muñoz, that legendary Mexican swimmer whose parents were, respectively, from Río Frío (Cold River) and Aguas Calientes (Hot Waters) (hence the nickname: "Lukewarm" Muñoz), Wenders is prepared to regulate the temperature—a practice with erotic connotations in Cuba—of the veterans' lives and music.

The filmmaker soon realizes he will not be able to avoid falling under the spell of their rhythms. That, like Odysseus, he will refuse to cover his ears as the siren song approaches. He will deliberately listen to this music and before long he will "be addicted." Immediately after, Wenders reveals the concept that has guided his filmmaking. So he heads off to find out who it is that has bewitched him, to find "what sort of people could make that music."

What had become of "Blind" Willie Johnson, Skip James, and J. B. Lenoir, those lost pioneers of soul? Wenders heads off to find them in *The Soul of a Man*.

What had become of Nicholas Ray, the unmistakable director of *Rebel Without a Cause*? Wenders found the response in *Lightning over Water*.

What sort of people could make that bewitching music, despite now living in poverty and obscurity? It's in *Buena Vista Social Club* that Wenders answers this final question, having been captivated by the siren song of the morenos (and the odd morena, like Omara Portuondo).

In the film, Wenders tries to shed light on something all of us ought to know about. The hidden truth about a group of lost souls

who once had cultural importance but then simply disappeared one day, "like a face drawn in sand at the edge of the sea," to use a phrase of Foucault's.

Once Ry Cooder had told him this fantastic story, Wenders "couldn't stop thinking" about what he'd learned about Havana. It became his "secret dream" to go in search of those venerable musicians.

So he drives his Cadillac along the Havana Malecón, arrives in Marianao with Compay Segundo, looking for a group that never existed, whose musicians are scattered all over Cuba, and who played at the Buena Vista Social Club, which, although it did exist, is now nowhere to be found. All this takes place in a Havana twilight, under which, while Wenders asks the neighbors questions, we hear Compay Segundo discussing a secret recipe for chicken neck soup, which may or may not improve virility.

And so, the filmmaker and the musician move through the ruins, searching for a dream beneath the splendor of a crumbling city.

Elsewhere, Wenders creates his own road movie, with the two Cooders, father and son, following in an old sidecar. *Easy Rider* springs immediately to mind when you watch this scene, although *Hard Rider* might be a more appropriate title.

Just as the book about the French philosopher's visit to the country, *Sartre visita Cuba* (Sartre visits Cuba), is actually three books, *Buena Vista Social Club* is actually three "buenavistas." There's the Wim Wenders film. There's the album, in which Ry Cooder discovers the lost mystery of that musical heritage. And there's the unique epic of these forgotten musicians, who have their own logic within all the rest of it. Ibrahim Ferrer is the perfect example: he was, he tells us, born out of wedlock, and was making a living as a shoe shiner when he was pulled off the streets to record again after decades without setting foot in a studio. Others live in very poor areas and walk through them

greeting the neighbors or singing, sharing a plastic cup of rum or the latest gossip. Wenders treats them like ghosts from the past, like those old Cadillacs made for the world of the night, cabaret, casinos, capitalism. Survivors of utopia, who move through the city every day remembering a past that refuses to go away, in the knowledge that their essence will last longer than the Revolution.

The train, the sidecar, the "camel"—a bus with humps—the hand truck, and the package tied to a rope, that vertical transport of Cuban commerce, are all part of Wenders's Cuban road movie.

There is a scene with Ibrahim Ferrer that's almost identical to David Byrne's scene with Papa Wemba in *True Stories*. A spiritual and musical encounter with San Lázaro, a Santería liturgy, a faith that remains intact, just like the possibility of emerging from oblivion and giving an incomparable rendition of "Dos gardenias" forty years later.

The Revolution makes very little appearance in Wenders's film, unless we are to understand it as the ruined city, a vision that Tomás Gutiérrez Alea had already put into circulation in *Fresa y chocolate* (*Strawberry and Chocolate*) and which has also been discussed at length (although in a different way) by other Cubans of the New Man generation: Carlos Garaicoa, Emma Álvarez-Tabío, and Antonio José Ponte.

Just a couple of revolutionary posters seen at the end of the film. And Rubén González playing "Begin the Beguine" on the piano while the healthy children of Cuba's future are doing their gymnastics drills.

II

When Wim Wenders flies to Havana in February of 1998, he means to film the process of Ry Cooder making the album. It's

a strange proposition, given that, as Joachim Cooder says, it involves "recording an album by a group that never existed."

Ry Cooder had already been to Cuba, on a previous trip "searching around for this soul music from a tape a friend had given us." He says: "It had some incredible playing, and some of the most beautiful songs on it. I'd never heard anything like it." It's odd that he didn't continue to investigate filin, that dissonant, nocturnal music that had its heyday in the fifties and sixties, but which still survives, as do some of its most important composers: Martha Valdés, César Portillo de la Luz, Frank Domínguez, Ángel Díaz.

Anyway, Ry Cooder comes twice during the Revolution to the country producing this music. Although it turns out not to be music of the Revolution, but rather of a previous era. Still, Cooder understands that this isn't "just a *menu du jour*, some kind of something cooked up for the day"—he has discovered something "uncorrupted."

In short, this is a trip to the heart of sound. Although that heart, as it was for Sartre, is not the Revolution, but rather the whole Cuban nation.

The nation over the Revolution, the past over the present, the country over ideology.

In Cooder's conversation with Peter Kemper, in the epilogue to the Buena Vista Social Club book, there's a very elegant statement: "Music needs room to breathe."

"What we don't have in the world, though, is time."

That phrase is an obsession of Ry Cooder's, although he's not really searching for lost time but rather "stopped" time, the ecological moment of his arrival at the planet's musical heritage.

If the left-wing ideologues Jean-Paul Sartre and Régis Debray were looking for an alternative future for their own societies in the Cuban Revolution, Ry Cooder, on the other hand, was looking to the past for an "alternative to the rock market." The paradox is

that outside that rock market—the Anglo-Saxon rock market to be precise—it would be impossible to conceive of success like the Buena Vista Social Club enjoyed. Otherwise, Santiago Auserón's *Semilla del son* (The seed of son) project would have had a different effect: a wider audience.

Pablo Milanés has mentioned this too; his project *Años* (Years) came before *Buena Vista Social Club*, and was more exhaustive, and yet today is hidden away, practically out of sight, among the relics. That project had already proven the importance of Compay Segundo and other pioneers of vieja trova and son oriental, although those performances never brought them the same emoluments as their adventure with Cooder did. Juan de Marcos González's reaction to Buena Vista Social Club's success was stronger: having dreamed up the project with Ry Cooder, he has since denounced what he sees as the colonial appropriation of his work.

In any case, despite Ry Cooder's plan to provide an alternative to the rock market, what made Buena Vista Social Club a phenomenon is the multicultural impulse from that very market it claims to be casting aside. Obviously, the Buena Vista Social Club isn't rock, but it became a global phenomenon because it was supported by commercial connections in the rock world. Ry Cooder knows the musical language of the First World, and his product comes fully loaded with a Wim Wenders film, a world tour, and, the cherry on the cake, a concert in Carnegie Hall.

We have to remember that Cooder's daring, like Xavier Cugat's or even George Gershwin's in previous eras, was well received by those old musicians, who have publicly thanked him for what they understand, perhaps better than anyone, to be an act of musical justice by the Californian. In some sense, Cooder has shown the public a musical lineage that was "in danger of extinction" for decades. Since then, Compay Segundo, Ibrahim Ferrer,

Omara Portuondo, Rubén González, Guajiro Mirabal, Pío Leyva, Puntillita, and Eliades Ochoa have become a protected species.

Cooder says he's tired of rock and rap—the latter, according to him, guilty of telling other people's stories. Nothing like the authentic adventures told by these old musicians who saw the light, at the end of their lives, when Ry Cooder appeared and put them on the world map.

There's a lot that other artists could learn from musicians. Unlike many frivolous curators of contemporary art, who after five days of mojitos at the Havana Biennial rush off to spread the word of Cuban art around the world, Cooder knows he must spend time with these musicians, play with them, if he is to learn anything. He must participate, learn, "express something" with them, find some "area to work in," some way of "moving from one note to another."

"Great musicians play one note and you know...Gabby Pahinui, Joseph Spence, Bill Johnson."

Ry Cooder ends by making a comparison between Cuba and Vietnam, on the basis of these "last" remaining Cubans (and "last" remaining Vietnamese) who knew the primeval world, untainted by promises and disenchantment, by the city and its ruin.

III

Labels such as "ethnic music" and "world music" (both highly questionable, of course) have been attached to incredibly famous musicians, whose generosity and "otherworldliness" have tended to coincide with a crisis in their career, a creative impasse, or simply the need for a change of scene. This was the case with Sting's *The Dream of the Blue Turtles*, Paul Simon's *Graceland*, David Byrne's *Rei Momo*, and Peter Gabriel's Real World Records.

Get out into jazz. Get out into gospel music. Get out into New York salsa. Get out into South Africa. Get out into peripheral

sounds. At every cardinal point, an incentive, and, incidentally, an excuse for a musical thesis. A personal respite, in the shadow of a good social cause.

David Byrne is a curious example in all this: leader of a neo-avant-garde group like Talking Heads, protagonist of one of the best films of all times about a live concert—*Stop Making Sense* by Jonathan Demme—photographer and video artist; voluntary New Yorker; trendsetter; pro-democracy activist; intellectual; researcher; composer for ballet, theater, and cinema; film director of *True Stories*... Byrne started to tempt the US market toward other sounds through his label Luaka Bop, founded in 1988, which gave space to artists like Cuba's Silvio Rodríguez; Venezuela's King Changó, and Peru's Susana Baca.

Byrne has always been drawn to Cuban music. He, too, preferred to discard Odysseus's advice and give in to the siren song coming from the communist island. At first it was indirect, through Latin music in New York, when he was surrounding himself with musicians like Johnny Pacheco, Milton Cardona, Ed Calle, and Willie Colón while he recorded his album *Rei Momo*. The high point of that album is "Loco de amor" ("Crazy for Love") featuring Celia Cruz. A song written by Byrne himself and Johnny Pacheco, which was the soundtrack to Jonathan Demme's *Something Wild*.

Perhaps out of respect for the exiled Cubans who had been important figures in the Latin music of the Big Apple, or because of Celia Cruz's unyielding anti-Castroism (she being the undisputed queen of that music), *Rei Momo* is a carnivalesque reclaiming (the very title takes us to Brazil) whose musical fusion has no direct link to a specific political affiliation. After that album, Latin music played a more restrained role in Byrne's *Feelings* and *Look into the Eyeball*, where electronic music has a greater presence and where, from the very album design, Byrne once again takes up his avant-garde fixations.

Only, by this stage, Byrne had already been injected with Cuban music and had known the temptation to stray. He had heard the morenos' song . . .

Islands possess a strong acoustic atmosphere, perhaps more so than other territories. Peter Sloterdijk's *In the Same Boat* takes up the Canadian composer R. Murray Schafer's definition of a soundscape as a sonorous landscape characteristic of a psychosocial group: a "soundscape that draws its own people into a psychoacoustic globe."

Although other great sounds, such as mother tongues, can be included here too, the magnetic pull of Cuban music has certain unique features. Because this music doesn't just draw in its own people, but others too, making them fall into its traps and sail through its waters. The same effect, according to Blanchot, that Homer's sirens were trying to have on Odysseus, or Melville's whale on Ahab.

So David Byrne goes further and sets off to enjoy this music in situ. Entranced, Byrne decides to take on the role of publisher, producing a compilation album whose ironic title already reflects a political position: *Dancing with the Enemy*, taking advantage of a loophole in the embargo law.

Bertolt Brecht dedicated a book to music, Adorno rejected jazz. The Left and music have always had their problems.

Is there such a thing as left-wing music? A sharp report by Marcelo Pereira published in the Uruguayan magazine *Escenario2* tries to solve this mystery. Pereira offers a convincing challenge to the overused theme of identity, as well as the relation between popular music, whatever that is, and cultural imperialism, especially when it comes to the United States and Latin American music.

Marcelo Pereira asks the following questions: "Is a song 'progressive' if its lyrics defend a stance assumed by the Left? If that defense is demagogic and insults the public's intelligence, is

the song still progressive? If the music is a rudimentary version of other music heard a thousand times before, is it progressive or conservative? Can an instrumental composition be revolutionary? Does 'progressive' music exist? What do we understand by 'progress'? What is 'backward' and what is 'advanced'? Should musicians be constantly 'advancing'? If so, how do we differentiate ourselves from those who in the sixties called certain kinds of rock music 'progressive'? How do we differentiate ourselves from those who maintain that highbrow music is more 'advanced' than popular music? Can progress be measured by the ability to produce no two songs that are the same? Or by the musicians' mastery of the kind of discipline taught in conservatories? Can an institution that calls itself a conservatory be progressive?"

In addition to the Cubans, Byrne was interested in music that mixes roots, the popular, and the global, such as music by Macaco from Catalunya, Mexico's Café Tacuba, or Brazil's Lenine.

When it comes to his company, Byrne understands that Latin groups find it difficult to be successful in their countries, and he takes advantage of the opportunity that presents. Byrne doesn't present himself as a messiah. Rather, he tries to exploit certain seams in the global music market, trying his hand at the music he likes, the music that satisfies his urge to mix various kinds of rhythm.

But Byrne is also a visual artist and, in a way, a publicist, capable of understanding that a record is an organic artifact.

He points out that questions of image and graphics are part of the music. The image on the cover of a CD is very important, it's the first impression you get of the music. When it comes to photography, he combines studio photos with others that are quicker, more direct, improvised and immediate, a way of expressing yourself with images instead of with words.

He explained all this as part of his self-promotion in *Dancing*

with the Enemy, asking: Can music be our enemy? Can communists experience pleasure? Can we experience pleasure? Can music be communist? And again, he encourages music fans to break the embargo and also (lest we forget) to buy his Cuban product: You need this record. Smoke a cigar. Now it's your turn.

IV

Santiago Auserón's Cuban turn came in 1984, before Ry Cooder and David Byrne. Unlike them, Auserón sings in Spanish, he is coming to the end of his time with Radio Futura, and has no interest—unlike Cooder—in distancing himself from rock music in order to approach the music of Cuba.

On the contrary, as far as Auserón is concerned, Spanish-language rock ought to take in the roots of son, the trova singers from the Oriente region (Company Segundo, Faustino Oramas "el Guayabero," María Teresa Vera, the Trio Matamoros), and especially the Elvis Presley of Cuban music, that autodidact who played every genre (and entirely unlike any other player): Benny Moré.

Auserón finds inspiration for his own music even in Benny's nasal voice. So he isn't interested in going right to the origin of Cuban music to keep it underground and uncorrupted (as Ry Cooder believes is necessary). Rather, he wants to expose the "roots to the wind." This is why he distances himself from the drift toward the rural that Cooder uses to justify his music, finding instead its urban dimension, its transition from the "field to the town," as Benny Moré puts it, in order to situate this music in an urban transition very like the origins of rock.

Auserón has studied with Deleuze—that phrase "roots to the wind" implies the germination of a rhizome. He had also written about the city and been lead singer of Radio Futura, a leading Spanish pop rock group. In short, he knows what he's talking about.

As was the case with Ry Cooder and Pablo Milanés, the master key to Auserón's project is held by Compay Segundo, the only surviving classic son musician, the guitarist and composer who invented a new instrument, whom Danilo Orozco had introduced to Auserón as an "eminent Cuban musicologist." Danilo gave Compay's music to Auserón, who, on listening to it, felt something very similar to Wenders: what he heard "down in Santiago," in the middle of Calle Heredia, "blew him away."

Auserón works with several Cubans to put together his compilation album, *Semilla del son*. Among them is Bladimir Zamora, a poet and researcher from Bayamo specializing in the origins of son and always ready to consult with experts and son fans, who still tell stories of lost recordings and underground sessions.

Unfortunately, *Semilla del son* came out without Compay Segundo's "Chan Chan," which was supposed to be the twentieth number. "Chan Chan" was undoubtedly *Buena Vista Social Club*'s major hit, so we have to ask ourselves: What would have happened had that song made its way into Auserón's hands in time? Would *Semilla del son* have anticipated the overwhelming success *Buena Vista Social Club* was to have not long after?

Whatever the answer, Auserón understands that Compay Segundo, after his time with Matamoros and Lorenzo Hierrezuelo, had got used to "leaving others to fight over the limelight." Cooder, Auserón, Pablo Milanés, and Juan de Marcos González all gave Compay, each for their own reasons and with their own aims, the limelight he so deserved. Auserón is interested in that phenomenon occurring in the Oriente region, with its songs that "are an example of construction, development, and climate"; with that fascination for the corners of Santiago de Cuba, populated by "specters" that are both "consistent and concrete."

"Nothing like the tourist postcards."

Auserón is also propelled by the traces of other sounds present in son cubano: "airs from all over the world" which range from "the Italian bel canto that Trova loved so much" to "dances in ballrooms with dubious imitation gold-leaf," from ragtime to American swing, African tango to the conga's trompeta china.

What blows his mind about Compay Segundo is his wide range, "his devilish agility, the precision of his fine fingers, his perfectly timed phrasing—never excessive, always luminous and bold— that passes through unexpected turns and reveals something familiar within the strange; with his passing chords that highlight the main melody, handing over to the voice: there is a baroque feeling clearly expressed."

And he points out that all this is a tool, "fuel for new rock riffs."

"El son es lo más sublime para el alma divertir" (son is the most sublime way to entertain the soul).

This refrain from "Échale salsita" (Add a little sauce) is easy to believe on hearing the music Auserón himself produces, edits, or writes: sublimity through pleasure, which, in another world, far removed from son, the Slovenian philosopher Slavoj Žižek has seen as a way out of the authoritarian excesses of the communist state and the capitalist market.

Auserón is intrigued by the composer of this rhythm, Ignacio Piñeiro, and sees himself as heir to a meeting that took place in 1932 between Piñeiro himself and the US musician George Gershwin, a crucial turning point in popular music that seems to have influenced Gershwin's *Cuban Overture*.

At this stage, it's no secret that Santiago Auserón is interested in impurity, whereas Cooder believed he had found pure music. That's why Auserón gives so much credit to the vicissitudes of those original New York musicians in the twenties, thirties, and forties, to the way they approached all the music of the Big Apple, to the sonic tricks that Ignacio Piñeiro, María Teresa Vera, Miguel

Matamoros, and Chano Pozo, with their respective influences from bebop and Latin jazz, knew so well how to handle.

Through these great musicians, Auserón realizes the need to escape the musical standards that have watered down son for audiences in Europe and particularly in Spain. We need to get away from "son's drift toward rhythms that are fashionable internationally because of cinema, radio, and dance halls," and let ourselves experience a direct assault from the sources, which are practically unknown. We need a new cartography so we can recover the onslaught of sound from "the eastern cities of Guantánamo, Baracoa, Manzanillo and Santiago, and their surrounding regions."

Auserón, in short, has been captivated by almost everything in Cuban music. By rhythms that have always been mixed: son and danzón, mambo and bolero, danzonete and cha-cha-chá. By original Cuban instruments: the tres and the guitar, the bongo and the cowbell, maracas and claves, the conga drum and the marímbula. By the outward stream of Cuban musicians and their presence in bebop and Latin jazz. By Cuban music's constant hunger for anything that can nourish it, from the trompeta china to the US jazz band. By the Spanish roots of its melodies and the African ritual in its percussion and vocals. By the strict austerity of the Trio Matamoros and the high point of Benny Moré's Banda Gigante.

But the ex-leader of Radio Futura distrusts salsa in the same way that Ry Cooder distrusts rap. He considers it a substitute, "despite the undeniable quality of some players," and senses that it isn't the way forward.

And the fact is that son players offer him more than rhythmic enrichment or anthropological satisfaction. They provide him with formidable critical material for his own cultural experience:

Neither our proximity to Africa, nor eight centuries of Arab invasion, nor the presence of black slaves on our own soil, nor the coming and going of ships from the Peninsula to the colonies, nor flamenco—robust yet delicate as it is—has managed to instill a deep, generalized appreciation of rhythm in Spain. Only now are we beginning to understand that in order to overcome the stiffness of our cadences we first need simplicity, before moving on to a polyrhythmic consciousness. Rock has given us back the basic beat after our folklore mysteriously dried up and our simple music became almost entirely trivial. This, paradoxical though it may seem, is how we should approach the secrets of rhythm in our own language.

Because after all, that is the ultimate function of the roots of rock and son, briefly immersed in the frivolity of the current music market: to "twist" into the ground in order to prepare "the shoots of a new musical century."

Ry Cooder feeds on the hidden root of the past. David Byrne swallows everything within his reach to expand his current musical discourse. Santiago Auserón senses that the journey toward Cuban sounds makes sense only if it leads us into the future.

REGGAETON THEORY
2016

I

Whatever is going on right now in Cuba—transition, reform, state capitalism, the Special Period Take 2, the perfection of socialism, whatever—it cannot be understood without reggaeton. It cannot be understood without that soundtrack that has colonized the island's acoustic landscape and is drifting through the atmosphere like the smell of oil from the Almendrones.

Reggaeton embodies a terrible paradox: it is deplored by the Cultural Model but necessary for the Economic Model.

Gender programs, equality, solidarity, formal education, environmentalism—the beacon of Latin America? Reggaeton destroys every vestige of all these things and is therefore declared socialist culture's Public Enemy Number One.

Private initiative, "cuentapropismo" or self-employment, a mixed economy, profit, the erosion of the borders between Havana and Miami? Reggaeton spearheads all of that and is a measure of the Rudimentary Accumulation of Capital in Contemporary Cuba too.

Apart from the few that come with a strange, desperate warning—"No reggaeton here"—it's hard to find a popular establishment that won't greet you, settle you in, and then send you on your way with that inevitable backing track.

It doesn't matter if reggaeton doesn't notice you—you will always notice reggaeton.

II

You are not born a reggaeton fan, you become one. There are plenty of us who grew up listening to our parents singing boleros, son, nueva or vieja trova, rock and roll . . . But there is still no adult in existence who grew up hearing their parents sing reggaeton.

That's why every reggaeton fan believes themselves to be like Adam; the first person to walk the face of the music. An eruption out of nowhere that makes them both barbaric and badass.

Reggaeton is the background noise of the criollo millennial, the backing track for a tribe whose gaze is fixed exclusively on the twenty-first century. They've no time for losing themselves in an archive or revisiting some historical precedent. No time for the Berlin Wall or the Cold War. No time for Vietnam or the sixties when the island filled with intellectuals from all over the world ready to wade into that Cuban utopia and do battle with their demons.

Reggaeton is ground zero of a hedonistic catharsis characterized by entertainment in a country that until very recently was characterized instead by sacrifice. The dystopian litany of a Wi-Fi-hungry mob, happy to cut and paste and DIY their own show into being.

With few exceptions, reggaeton anthems call more for a romp in the hay than a revolution. For perreo before protest. And that's why it's so odd that this genre, which is so far removed from politics, has become a state issue. (This is why we sense that it's not what reggaeton challenges that makes it problematic, but rather what it extols. And that what will make it subversive is not its message but its censorship.)

III

At this point in the essay, you'll have realized that these observations are local ones, aimed at the Cuban context in particular.

A tentative theoretical probing (more pseudo than cerebral, let's be honest) in response to the shock produced by the gap between the new glorification of pleasure and the old apology for duty.

I'm well aware that as soon as the field is widened to other geographies—or when Rita Indiana and Calle 13 enter the equation—the whole thing deflates.

(But theories are like records: they're there to be broken.)

And in the Cuban context, reggaeton answers to a generation that is both *spontaneous* and *simultaneous*. Anyone remember Cuba's insiders vs. outsiders conflict? Or the insiders making peace with the outsiders? That bipolarity shatters with the first big wave of reggaeton, for the simple reason that the movement is, at the same time, both *inside* and *outside* Cuba. In Miami and in Havana. Prepared to dredge the Florida Straits "hasta que se seque el Malecón," as Jacob Forever puts it—*until the Malecón dries up.*

Rather than taking us back to some utopian project of Latin American integration like ALBA, reggaeton reveals a West Indian dystopia where everything it touches becomes Miami. It cannot be coincidence that the long overdue Cuban edition of the novel *1984* coincides with this apogee that is forcing Marx and Lenin to cross paths with Orwell and Huxley.

Geo-strategically, reggaeton is sort of like the Sí Se Puede of anti-politics. An ultra-urban plague infecting every swimming pool in its path, invading the Caribbean's green spaces with Jet Skis, yachts, and SUVs (with Greenpeace nowhere to be found).

Along the way, reggaeton washes its hands of all the musical genres the country has gifted to the world—cha-cha-chá, guaguancó, son, danzón, filin, songo, nueva trova, Mozambique, Pilón—its brazenness distancing it from the verbal subtleties those rhythms once achieved.

This ahistoricism is wielded against both past and future. Except that reggaeton's No Future, unlike punk's, is not fed by

a tragic vision of what is to come but by the exaltation of a per-
petual present that leaves no room for tragedy.

IV

There may be no Greil Marcus of reggaeton, with his *Mystery
Train* or his *Lipstick Traces*, but there is no shortage of books
about it—by Raquel Z. Rivera, Santiago Jarrín, Ángel Reyes, and
Geoffrey Baker—and bets are being raised on its imminent suc-
cess in US universities (as is already the case with hip-hop, street
art, and so-called ethnic music) thanks to the establishment of
Cultural Studies.

For now, one of the first visual artists to tackle the issue is
Lázaro Saavedra, in a piece that directly identifies something this
phenomenon pushes aside: *history*. In his video *Reencarnación*
(Reincarnation) he superimposes scenes from Orlando Jiménez
Leal and Sabá Cabrera Infante's 1961 film *PM* with music by Elvis
Manuel, born in 1990.

It turns out that *PM* was the first film to be censored in revolu-
tionary Cuba. And that Elvis Manuel—who drowned at sea trying
to reach Florida—was Cuban reggaeton's first martyr. In Saave-
dra's piece, twenty-first-century reggaeton links seamlessly to that
group of Havana musicians in 1959, intent on dancing and drinking,
untouched by any collective morality designed to redeem them. As
though the beginning and the end of the most recent Cuban era
were braided together by that hedonistic superego, abandoning
it all to "live happily in the moment" and "enjoy whatever there is
to enjoy," according to Dr. Benny Moré's recommendation, which
improves on Ignacio Piñeiro's prescriptions.

In schmaltzy "Piel canela" it was "tú, y tú y nadie más que tú"
that mattered—*you, you, and only you*—but in bitter reggaeton
the important thing is *me, me, and only me*.

Yet this egocentrism has long been present—Freud being absent—in other eras, other kinds of music, other occupations. There are extreme examples, such as Capablanca, the Cuban chess prodigy whose excessive brain activity brought him both fame and death. He was known, too, for his amorous forays, which colored even his tournaments, though it's hard to imagine this (undeniable) "king of the world" twerking in a pool full of girls in G-strings. Nonetheless, some of his cockiest phrases are worthy of Jacob Forever, Osmani "La Voz" García, Dayamí La Musa, or Chacal y Yakarta . . . This line of his, for example, is priceless: "Los demás tratan, pero yo sé"—*everyone else tries, but only I know.* Leaving aside, for a moment, the class this chess master exudes . . . is it possible to imagine a lyric more reggaeton than this?

EL NEGRO IVÁN
AND BIG DATA
2015

A few months ago, I started writing a series of articles about data control on the internet, the price we pay for every click, and more generally the use and abuse of our information by companies, governments, and security agencies. Some of my writing was inspired by books by Evgeny Morozov and César Rendueles, other pieces by a visit to the Big Bang Data exhibition. The truth is, they all left me with an apocalyptic feeling, a sense that everything is lost, or at least that everything is under surveillance.

That said, a later experience helped relieve me of some of that burden of worry.

When I heard about the death of Juan Formell, director of Los Van Van, I decided to listen to the group's early hits, from back when I was a kid living in Cuba. So I went on YouTube and looked up "Marilú." I looked up "De mis recuerdos" (Of my memories), which Formell composed for Elena Burke. I looked up Pastorita and her guararey. I looked up "Seis semanas" (Six weeks).

And what happened? Well, by the time I was on the third search, an advert appeared on the screen, personalized for this web surfer who was clearly obsessed with early Los Van Van. What was the ad offering me? Nothing more and nothing less than a hair-straightening product.

It was apparently easy for this year's Big Brother to come to its conclusion: if you like Los Van Van, you must be black; and if you are black, you don't like your curls. A series of racist assumptions that, in the end, provided me with a viable exit. If that is

my "identity," I said to myself, then the System is fallible and the datafication of the world has its limitations. Let's just say that, as I agonized over the total control of the internet, an exit route opened briefly that allowed me, for a few moments, to feel that my entire life was not being confiscated.

Here, in my new incarnation as El Negro Iván, always ready to straighten his hair, I had found a breach in the system. An escape route that allowed me to dismiss the problem, take my music and run away—yes, run away someplace else. Even if it was only for "Seis semanas."

GUANTÁNAMO AND
ITS METAPHORS
2009

Guantánamo has become, in addition to everything else, an artistic genre. A dumping ground, a few square kilometers wide, both real and metaphorical, into which the vestiges of communism and a US naval base packed with reminders of neo-colonialism are rushing headlong. Islamist terrorism and the torture of liberal democracy. The Nobel Prize for Literature (in the form of Harold Pinter's lecture) and the Berlin Film Festival's Golden Bear (awarded to Michael Winterbottom and Mat Whitecross's *The Road to Guantánamo*). Banksy's activist art (Disney targeted through an installation inside the Big Thunder Mountain Railroad ride) and even spy thrillers (Frederick Forsyth's *The Afghan* and Dan Fesperman's *The Prisoner of Guantánamo*). A Spanish artist, Alicia Framis, has even suggested the Guantánamo Bay detention camp should be turned into a museum.

Criticism, frivolity, literature, and image all dwell together in that gutter of globalization.

The paradoxes—and complicities—of contemporary culture: On the other side of the world, in Abu Dhabi, they're working round the clock to bring Western culture to Muslims. Even the Louvre and the Guggenheim are prepared to open franchises there.

So Goya and Picasso will go east; maybe a Jeff Koons, a Hermann Nitsch, and a Damien Hirst too.

Nothing of the sort will happen in Guantánamo. Neither Avicenna nor Averroes is heading for this part of the Caribbean, nor

are the splendors of Sufi poetry, let alone any contemporary artists who, against all odds, have built what Catherine David has called "contemporary Arab representations." In Guantánamo there is no warm reception to cushion the culture shock. All you'll find are terrorists, people who have aided and abetted terrorists, innocent people suspected of terrorism, and, of course, the Quran . . .

Nearby, there is no shortage of prisons for Cubans, including for political prisoners, although that figure tends to disappear from trends in global art, trapped between its critical aims and the pathetic possibility of becoming an evangelizing outpost of other, less spiritual interests.

The Guantánamo region has long had a global pulse, although many of these artists are outrageously ignorant of that fact. An astronaut from Guantánamo even reached the stratosphere during the Cold War years. The high point of the region's globalization, however—assuming it's possible to top looking down at planet Earth from the cosmos—is perhaps musical, in the form of a song you'll even hear played on soccer fields: "Guantanamera." Outside Cuba it was popularized by Pete Seeger—who, incidentally, benefited for some time from owning the copyright (leftism and colonialism aren't always antagonists)—but it has been re-created by all kinds of musicians in all kinds of styles. Tito Puente and Los Lobos, José Feliciano and Julio Iglesias, Los Olimareños and Celia Cruz, Pérez Prado and Joan Baez, The Weavers and Yellowman, Nana Mouskouri and Wyclef Jean . . .

It turns out that the more is written, filmed, exhibited, or painted about Guantánamo, the more useless metaphors become for understanding anything about it at all. They don't help us learn, for example, anything of its history as a colonial villa or a communist province. The word "Guantánamo," today, is nothing more than a toponym for degradation: a neocolonial military

base, a detention center for Haitians, Cubans, and Kosovans (depending on the conflict of the moment), a detention camp where extrajudicial torture is carried out. Decades of providing different geopolitical quarantines. On the other hand, the Cuban government's restraint in dealing with this issue is curious, especially given it does not usually miss an opportunity for a diatribe against the United States. Although perhaps there is no mystery here at all. The very presence of the naval base is an ideal counterweight for the socialist regime, a cursed place capable of proving—quite spectacularly—that human rights are also violated under democracy.

Barack Obama has announced his first initiative: he will close the detention camp at Guantánamo Bay. It would be a nice touch if, while he's at it, he could also lock away what his predecessor coined the Axis of Evil, that recruitment program that—along with local censorship—brings together all the most interesting intellectuals in this planetary reserve of pariah states. Artists who resist participating in polarized thinking and refuse to play with marked cards. Obama still has time to see through a third initiative: to close the naval base and return it to Cuba. This would be a significant first step toward simplifying the equation of this multiple orgasm of ignominy.

Unlike some tyrannies or terrorist movements, which tend to be forgiven by the past for whatever their seminal injustice, democracy is judged, and condemned, only by the present. The price we pay for this is high, or nothing at all. A president with African origins, a cross-cultural biography, and "Hussein" among his names has it in his hands to bring forward that "blank page" moment, that "ground zero," and to restart history. To propose any effective body capable of imagining one final—and hopefully useful—metaphor of Guantánamo.

SOCCER OR BASEBALL?

2012

Thigh or breast? Heads or tails? Surf or turf? Beatles or Stones? Life is full of these crossroads, which, while they may not be world-shattering (we're not talking matters of life or death), we still sometimes, irrationally, take them very much to heart.

One such dilemma presents itself to this baseball fan living in Europe, where soccer, like God, is everywhere. (And even if God hasn't certified it as a religion, then a least Manuel Vázquez Montalbán and Juan Villoro have). There, if you want to watch baseball (good baseball, I mean) you have to get up early, accept lost hours of sleep as the price of your passion, alter your habits.

Soccer or baseball? Omnivore as I am—I'm happy with both thigh and breast, both the Beatles and the Stones, surf and turf, beer and rum—I enjoy the one as much as the other, although not *for the same reasons*. Both represent very different things in my imagination and, if I'm being objective, I'd have to say that they're not just different sports but rival ones.

This doesn't mean you can't enjoy both; rather, the difficult thing is bringing them together: their respective schedules, their geographies, their teammates, the rituals involved in watching them, it all creates a sense almost of schizophrenia. Especially when the time comes—and it always comes, round here—to explain what exactly this statistical sport (also called a "game" or "pastime") consists of, seeing as it has no time limit, a player can be stationary for the better part of the game, and you cannot end up with a tie.

It's not a bad idea, in principle, to turn to cinema in order to explain: soccer behaves like a thriller while baseball is more like a Western (with that continual tension between pitcher and batter, inning after inning). There's something of chess in baseball, while soccer is much more like a war (Roman legion style). On the other hand, while the rules of soccer are simple (there are those who say that's why it's the sport understood by the greatest number of people globally), baseball rules take in codes and shades of gray that approach a kind of jurisprudence.

Baseball incites passions, but there's too much talk. And it couldn't be otherwise, as a game full of time-outs, conducive as they are to hot dogs, beer, and dialectic exchanges, especially with fans of the opposing team. People regularly sit down in the stadium among a group of people rooting for the other side without, as is often the case with soccer, the police needing to separate fans to prevent outbreaks of violence.

Soccer is not exclusively a statistical sport, but baseball is. When faced with unexpected outcomes, the Serbian soccer coach Vujadin Boškov (just like the "prophet of Betondorp" Johan Cruyff, and many others after him) used to fall back on tautology: "Soccer is soccer." Meanwhile, baseball tends to be explained through paradox, hence a refrain that sounds like something Lao Tzu might have said: "The ball is round and comes in a square box."

Baseball and soccer are more closely linked to culture than you might think, although not in the same way, of course. In his essential history of Cuban baseball, *The Pride of Havana*, the Yale literature professor Roberto González Echevarría reveals that literature and "la pelota" ("the ball," as the game is known in Cuba) are intertwined to the extent that in the first decades of the twentieth century they came to share the same clubs.

Soccer has not generally known this symbiosis, although it has had some literary connections of its own. Leaving aside the exam-

ples of Éric Cantona—Manchester United star but also agitator, composer, and actor—and the renowned music lover Gaizka Mendieta of Valencia, Lazio, Barcelona, and then Middlesbrough, there are the exceptional examples of soccer player–readers: Valdano, Pardeza, and Guardiola. And there are abundant examples of writers devoted to their soccer cause (from Peter Handke to Javier Marías, by way of Roberto Fontanarrosa and David Trueba), all practitioners of "the greatest loyalty," as Marías, in his tribute to Montalbán, described the devotion of a soccer fan.

There have been rhapsodies over baseball, too. And Joe DiMaggio himself, famous for his extraordinary talent, for playing for the Yankees, and for his marriage to Marilyn Monroe, even admitted that had Hemingway not paid homage to him, his glory would have been diminished. And then of course there is Borges, who considered baseball "a rare book written in full view of its spectators."

As far as cinema is concerned, there is no doubt that baseball beats soccer, although it's fair to say that baseball has an advantage here, both baseball and Hollywood being US products par excellence. Even so, soccer has its own filmography, which runs from *Escape to Victory* (with Michael Caine, Sylvester Stallone, and Pelé himself in the cast) to *Bend It Like Beckham* by way of Kusturica's documentary about Maradona. Among Spanish films, comedy has prevailed—for example, with *Matías, juez de línea* (Matías, assistant referee) or *El penalti más largo del mundo* (The longest penalty in the world).

Of course, these films don't achieve the same glamor as *The Natural* (with Robert Redford) or anything starring Kevin Costner (a figure who has been in decline for some time, but whom we cannot deny is, if not *the* best, then one of the best actors to have done a proper windup on the big screen). And while we're on the subject, it's worth remembering that while Marilyn was married

to DiMaggio, Madonna is said to have had an affair with Alex Rodriguez (as well as starring in *A League of Their Own*, an epic in the form of a gentle comedy about a female baseball league during the Second World War).

There are other, shall we say, irreconcilable differences. In soccer, it's impossible to define a perfect game (although at various moments there has been talk of the perfection of Pelé's game for Brazil, of Cruyff's for Ajax, Di Stéfano's for Madrid, and Messi's for Barça). In baseball, on the other hand, a game can indeed be considered perfect—always, of course, to the glory of the pitcher. It's enough for the batter not to get a single hit, nor a single run, and for the pitcher's team not to make a single defensive error.

In both games, as is the case with most sporting hobbies, the important thing is to prolong the experience of childhood, although in soccer the infantilization is more acute. Baseball has more solemnity, if only because of the players' more adult-looking kit and that tuxedo-type thing the referees wear.

Uniting these two passions is a double dose of irrationalism that can, depending on how you look at it, be a blessing or a curse. It doesn't matter. When the whistle blows or the umpire yells, "Play!" a Big Bang occurs and the world begins; or rather, the game does.

GENERATION "?"
2011

"Given that a revolution was necessary, circumstances dictated that youth should carry it out. Only youth had experienced sufficient anger and angst to undertake it, and had sufficient purity to carry it out."

So wrote Sartre. In 1960. In Cuba.

Half a century later, the generational issue is being debated intently, and similar hopes are being placed on the youth in Cairo, Barcelona, Paris, Tunis, Casablanca, London . . .

If this debate is taking place, it's because both here and in other regions the generational question has burst into politics in a sudden, undeniable way.

These debates have varied widely: old people inciting young people to rise up, the veneration of social networks, the exaltation of youth to romantic extremes, parallels between gentrification and the fate of capitalism's youth industry, suspicions of neo-terrorism, a change of scale in the perception of what constitutes a revolution in the twentieth century . . .

In *Time for Outrage!*, Stéphane Hessel made a case for anger in politics. In *The Ecstasy of Influence*, Jonathan Lethem vindicated the practice of copying in the creation of culture.

The fact is that today young people are either feared or expected to redeem us. We either exalt or appease them. But what no one can deny, given what we've seen in recent months, is their leading, fundamental role in global change.

The recently concluded Sixth Congress of the Communist Party of Cuba has not understood them as such. And this is despite the

fact that many of its leaders (those that are still left) were not even thirty years old when they took over the country and revolutionized it to the point of overturning all its values.

These leaders are the same people who gave Sartre hope half a century ago.

And they have decided that the young people waiting to "relieve" them of their duties are not yet ready. As though a true generation could be determined rather than emerge spontaneously. As though prescribing their "moment" were not one of the most useless decisions older generations can make on behalf of young people.

BACK TO THE PRESENT
2008

Ever since the disintegration of the Communist Empire was completed, Cubans have become walking oracles. Wherever they go, the same question always awaits them, a question about the future: What is going to happen in Cuba? Well, in 2008, things are finally *happening*, right now, in Cuba. You might say that we Cubans have come back to the present. The sequence of recent events indicates that we may not be dealing with a handful of isolated symptoms: students with the president of the National Assembly up against the ropes, dissidents freed with no prior warning, and now, without a single analyst predicting it or a single press agency leaking it, neither among his supporters nor among the opposition, Fidel Castro is resigning.

For good measure, and to remain a few steps ahead of everyone else, he himself broke the news of his own end.

This ability to anticipate events has been one of the advantages Fidel has held over his opponents. And it must have been a bitter pill to swallow when it came to making the final calculation, the one that implied the biggest, most definitive commitment; taking the measure of the end of his own time in power. That power, which was absolute, has been proportional to the scrutiny, also absolute, of every single one of his acts, as if the island were circumscribed solely to that voice, those mannerisms, that image.

Specialists obsessed with Fidel Castro have often neglected the country's common citizens, the new generations, any simple mortal with an idea for a solution. That's why it's so surprising to

see clear signs of a society in transit and demands being made for urgent change.

Of course, the ability to measure the rhythms of politics is not hereditary. And the Cuban power that emerges from Sunday's National Assembly will be faced with the novel reality of perhaps no longer being able to determine the political tempo, or at least not entirely alone. It may be that, in the current situation, the rhythm and intensity of this beat is set by other parts of society. It's ironic that, in the end, after so many resources poured into drawing the island's future, the agents of change will not be the army, the dissidents, the exile community, or the church (those subjects predestined to command the transition according to liberal engineering or socialist hydraulics), but some unexpected citizens who have been out of the habitual spotlight and now are demanding their moment.

New technologies, restricted in Cuba, have shown signs of originality. Fidel Castro himself, who initially used television as a means of ideological didacticism (no socialist regime has ever been more "televised") is stepping back to take up blogging as his final occupation. In a state whose mechanisms of control are pre-digital, YouTube has shown students hurling criticism at the president of the National Assembly. To counter a culture whose press has become, on all sides, a weapon of war, hundreds of blogs are now emerging where any grievance can be aired and any issue discussed. In this country that has had so thorough a monopoly over opinion and official communications, those who keep the truth to themselves no longer have impunity.

Barring some unlikely surprise, Raúl Castro will occupy the top command post in what is being called the "Cuban transition." It's also unlikely that he will govern by concentrating the same magnitudes of absolute power in his own hands as Fidel did. And although he's seventy-six years old, one of the founders of the

Revolution, and a military man, there is hope that, with a bit of common sense and the facts to hand, he will realize he cannot govern unless he makes some changes. That realization would in itself be an important step. There is not much time, not even much space, and he will have to attend to many earthly matters, including discontent. Given this situation, repression alone doesn't seem a feasible way out, since it will no longer be possible to justify it with the excuse that the voices of dissatisfaction are a product of imperialism, Miami, or dissidence, but of people who describe themselves as "revolutionary" in the communist assemblies. In any case, Cuba ceased to be a revolution a long time ago, becoming just another state in the communist model. Except that model no longer corresponds to a global system, nor can messianism be used as a political style anymore, nor do calls for sacrifice promise future redemption for Cubans.

The here and now: These are the space and time with which we must begin. Two key words to remind the future leader of his obligation to govern in the present.

BACK TO BATISTA
2012

At first it was gentle. Then it increased in intensity until it finally reached hurricane force. Batista—Fulgencio Batista y Zaldívar— has made a comeback as the great Cuban hashtag; a national trending topic that has strengthened his posthumous presence more than at any time over the last half century. On the six- tieth anniversary of his coup, in interviews, articles, essays, and hypotheses, a group of Cuban intellectuals have revived this general who, in 1952, brought to an abrupt end the last island government elected under a multiparty system. This inter-rev- olutionary figure who gained everything in the 1930 revolution and had it all taken away in the 1959 one.

The arguments that make up this revival place us squarely on a tomb that is not quite sealed properly (which, in the long term, is a good thing). But they also radiate, and this is what's worrying, the unease of a culture that—however tropical it may seem— obliges us periodically to suffer Wilhelm Reich's anguish at the masses' desire for fascism. In the Cuban case, this is a zeal that is perhaps even more marked among intellectuals.

This revival of "The Man," as the tyrant was also known, is not, curiously enough, caused by his enduring memory among old coreligionists (almost all of whom are dead). Twelve years into the twenty-first century, Batista is being revisited and discussed by a generation he never governed, and which was shaped, for the most part, by the Revolution's education system. It's worth adding that many of them now live in democratic countries in the West.

In any case, here he is, amplified into a multidimensional subject. The good Batista and the bad Batista, the Batista who established a constitution in 1940 and the Batista who betrayed it in 1952. The sergeant in revolt and the implacable general. The Batista who, for some people, marks the beginning of Cuba's episodic democracy and, for others, the birth of the eternal regime that followed. The factotum of half a century in Cuba, who made it through the comparative tyranny scanner, obsessed with figuring out ("mirror, mirror, on the wall, who is the . . .") whether he was better or worse than Fidel Castro, a figure that flourished in a different island era.

During the process, the burden of his dead has been lightened and the systematic torture of his last government has become a onetime indiscretion. He has also been characterized as an "exceptional" despot, and this has led to comparisons with later Latin American dictators who had no choice but to resort to repression "against their will": Pinochet and Videla because of the threat of another Cuba, Batista because of the threat of his *own* Cuba. The stolen millions have become peccata minuta and as for the demonic character exploited by Hollywood—by Coppola and Pollack—he may not have a private cinema in his mansion where he can enjoy watching *Dracula*, as in Richard Lester's caricature, but he is revealed to be the owner of a considerable library. Meanwhile, the question of Batista's race has been highlighted, especially its role in the rise of mulattos in Cuban society during his regime, as Batista himself has argued, alongside writers like Gastón Baquero.

In the most vehement, brilliant, and polemical article on the topic, the poet Néstor Díaz de Villegas has coined the existence of a "Batistan aesthetic," reminding us that Batista was extolled by Neruda, appeared on the front cover of *Time* magazine, and graced the pages of Emil Ludwig.

This recovery is not exclusive to right-wing thinkers or the exile community. Despite (or because of) the fact that Batista was taboo for the Cuban regime, some Marxist historians have also taken an in-depth look at his period in power. José A. Tabares del Real, who fought against his dictatorship as a member of the Revolutionary Students' Directorate, devoted himself, until his death, to a biography of the hated leader. Tabares del Real pointed to Batista's logic of power—the "Batista method," which had allowed him to thrive in Cuban politics ever since the thirties—and warned of his strategic competence. Recognizing these abilities was, for Tabares del Real, a "revolutionary" exercise, so to speak. After all, there is no merit in winning a war against an idiot.

What then, does this rehabilitation of Batista mean in the twenty-first century, and what can his revival bring to the imagination of current generations of Cubans? If it is a question of examining an era or a style of governance, or of illuminating the dark side of the biography of the person who accumulated more power in Cuba than anyone else during the first half of the twentieth century, it would be a plausible exercise in historical revisionism. An eyes-wide-open revisiting of history is always worthwhile, no matter whom it concerns; even if it concerns a tyrant (especially if it concerns a tyrant).

This is particularly true if we bear in mind that (to take literature as just one example) there are very few rigorous books about Batista. Cuban fiction has until now been rather more diligent in portraying the oppressive atmosphere of his regime than in portraying the leader himself. There is Guillermo Cabrera Infante's *Así en la paz como en la guerra* (In peace as in war), to some extent Jesús Díaz's *Los años duros* (The hard years), and Lisandro Otero's *La situación* (*The Situation*).

It's telling, on the other hand, that Reinaldo Arenas, Heberto Padilla, and Cabrera Infante, the three best-known archetypes of

dissident literature, have never claimed Batista as an acceptable model for the future rebuilding of Cuba.

Now, if, as Marx put it, people resemble more their times than they do their parents, then there is no doubt that this revival is not exclusively an academic exercise. Just as, for example, it was not exclusively an academic exercise to use neo-medievalism as a means of discussing a postmodernity that has done away with rationalism.

In this sense, Batista is making a comeback as the perfect, sinister paradigm of this time in which democracy is not necessary for the implementation and success of capitalism. In the Batista cocktail shaker, repression mixes perfectly with speculation, violence with increasing wealth, and corruption with an "anything goes" attitude, as long as people don't start worrying about politics and questioning their citizenship. (This combination guaranteed Franco's long march, the thriving Chinese model, and the neoliberal experiment in the Southern Cone.)

But if, instead of historical revisionism, what we are seeing is the possibility of a political restoration, then we are stuck in a vicious cycle that, as Rafael Rojas has predicted, will see Cuba's future heading for the ground zero of a "market without a republic."

A repositioning like this would be the sign of our definitive capitulation as a culture; our surrender to a manifest destiny according to which Cubans are not fit for democracy.

Seeing as we've come this far, it's worth suggesting that future Cuban intellectuals opt for the only branch of culture that might, if not redeem us, then at least explain us to those looking back in a hundred years' time: *psychiatry*.

THE MOON WALKERS
2012

La conga irreversible (The irreversible conga) is the title of a piece presented by Los Carpinteros at the eleventh Havana Biennial.

It has all the attributes of a proper conga (a dance troupe, a band, suggestive costumes) and an aesthetic reminiscent of *Treme*, but what happens here is that—in the most natural way possible—the performers "roll" in reverse. They go backward.

It's hard not to see in *La conga irreversible* a sketch of the future (and the present) of a country often explained—and entranced—by its own exceptionality. And the fact is that, as though they were doing the moonwalk, Cubans have long been marching out of step, at least when it comes to great historical landmarks; they have borne the agony of all the dreams and burdens that come with walking, so to speak, outside the "normal" gravitation of events. Wasn't it precisely Cuba's lack of gravity that so irritated Jorge Mañach in his *Indagación del choteo* (*An Inquiry into Choteo*)?

The fact is that, at the end of the nineteenth century, Cuba achieved its independence several decades after most other Spanish colonies. After 1959, the Revolution was transformed into a communist state (integrating itself into a distant system whose neighbors—"brothers," according to the Constitution—were ten thousand kilometers away). And in 1989, the same socialist-style regime persisted in Cuba despite the collapse of the Soviet Bloc . . .

As we have seen in this book, this exceptionality has had illustrious chroniclers: from Humboldt to Sartre; Madden to Lezama

Lima; Félix Varela, who came to observe what he saw as a moral debacle, to Che Guevara, who came planning to showcase it as an avant-garde virtue.

Let's leave history here for a moment—*La conga* is calling.

When the performance first starts taking shape, people look perplexed, but before long their surprise becomes a contagion that no longer requires answers. So they're walking backward? Doesn't matter. If the music sounds good, we'll follow it all the same, even if it leads us into the abyss.

If Los Carpinteros know anything, it's how to create impeccable objects (their own name—The Carpenters—has always pointed to the "good craft" of old trades).

With this performance, you could say their work has taken a leap forward, despite being achieved via a back-to-front rumba. This collective, Cuban-style *Moonwalker* through which leaders are heading, against the tide, into the past, followed by an enthusiastic mass that just keeps on growing.

Along the lines of Arturo Infante's *Utopía* (Utopia) or Lázaro Saavedra's *Reencarnación* (Reincarnation), which re-creates the mythical documentary *PM*, this work is an eloquent, succinct lesson in Cuban history.

Like Neil Armstrong's footprint on the moon, *La conga irreversible* symbolizes, perhaps, a small step for man, but a giant leap (backward) for *Cubanness*.

EL LOQUITO AS
I IMAGINE HIM
2007

"El Loquito showed Cubans of his era how to read sign language."
This phrase, uttered by a friend, rang out in the Barcelona
night at the precise moment when, as Charly García would say,
"the wine was running out." He was trying to aid me in the com-
plex task of explaining to my Catalan in-laws, in as few words as
possible, who my father had been. We were in an Italian taverna
in October. I think we talked some more about the fifties before
that strange negotiation that happens in mixed families, where
different cultures and histories are at play, drew to a close.

There are always things that remain incomprehensible in that
game: some aspects are translatable, others not.

Given the time, and the waning of the wine, defining El
Loquito, that mad cartoon character, as a master of sign language
struck me as a good translation.

In the days that followed, I thought again and again about
El Loquito (with his hat made out of newspaper and his Napo-
leonic stance, one hand inside his shirt), I even began to think
about the role he had played in my own life. This exercise left
me with a strange feeling. Perhaps because of the distance (I left
Cuba in 1991), I didn't remember El Loquito as a fictitious char-
acter drawn by an early caricaturist, but as someone who had
had a life of his own, like a legendary older brother, seasoned
in battles I was never to fight. The kind of missing brother who
has marked out the territory ahead of you and with whom, no
matter how hard you try, you can never catch up. Like a relative

who died in some war and whose absence has the weight of a mountain.

That first Loquito, as I imagined him, was not the Loquito others have seen and studied. For example, in Baracoa, the fishing beach where I grew up and where my mother was born, Loquito was simply the name of my father:

"Is Loquito here yet?"

"You coming octopus fishing this morning, Loco?"

El Loquito was also the name of our first rowboat. Later, when I was still very young, El Loquito became a friend discussed, with a certain melancholy, by some very self-assured people who had fought against Batista in the city: *Zig Zag* and Pardo Llada, Pumarejo and the urban struggle, the Students' Directorate and the July 26 Movement, the Havana Institute and Montmartre, the Pico Turquino and the Pico Blanco, filin and Shanghai, Radio Rebelde and Radio Reloj, a one-eyed cat and the Tres Tristes Tigres, Ventura and Carratalá . . .

They'd talk so much about that era that (again, as Charly García might say) the rum would run out, the heroic would give way to the ludic, and the pleasures of the Havana night would begin to win out over the risk of death hanging over them during those years. It was then that I used to arrive—impeccable timing—and contemplate them in astonishment.

I, too, would have recently run out of rum, those days representing my first brushes with alcohol, and I was going through that difficult stage of early youth when I questioned almost everything.

Almost everything, or *everything*?

Anyway, the point is that one day, after the umpteenth evening spent surveying the cartography of 1950s Havana, I asked the following: "If you were having so much fun, why did you have a Revolution?" What problem could have been so serious as to

make them decide to do away with all that nightlife and put their own lives at risk? After a somewhat violent silence, my father (none of the others responded, perhaps because my question was above their pay grade, so to speak) mustered a response: "There was one very serious problem: Batista."

So there was a familiar world that in some sense revolved around El Loquito. And El Loquito reveled in it with the eternal youth of those who have died young, not yet corrupted by maturity, nor by the harshness that comes with having to put sacred ideas into practice.

During those questioning years of my youth, I was an active part of what was known as "the Eighties Generation" in Cuba, whose artistic production I described in 1989 as a "dissonant culture." We hadn't lived through the fifties; we hadn't even been born yet, back then. We were just in a hurry to live and to have our say. So we weren't particularly concerned with studying that pre-revolutionary decade. (I can remember only a handful of possible exceptions: Tonel, Emma Álvarez-Tabío, Pedro Álvarez.) The truth is, we were much more interested in our aesthetic war against the seventies.

It was, however, during that period, despite other urgencies and other interests (or perhaps because of them) that I began to read about the Loquito everyone else knew, thanks mainly to Adelaida de Juan's research—I still have her book *Caricatura de la República* (Caricature of the republic)—and a couple of theses written about him in the University of Havana's Faculty of Arts and Letters.

There he was: El Loquito. With his newspaper hat, his Napoleonic pose, and his repertoire of symbols and codes: a route 30 bus heading for the Sierra neighborhood (representing the Sierra Maestra), the suffocating presence of El Indio and the sun (both representing Batista, the dark-skinned dictator), a man listening to tangos on Radio Rebelde because Che Guevara sang them, mocking censorship, mocking the lack of cinemas, clubs, cabaret . . .

It was then that I understood just how great this character was, with his unique anarchy, using his schizophrenia as an excuse to question the order of things, and how brave it was to wonder what humor is for if not to torment tyrants. El Loquito died in 1959.

His creator thought that in the new era, the era of the Revolution, you wouldn't need to pretend to be mad in order to tell the truth. He was convinced the truth would now belong, forever more, to the world of the sane. I mention the date of his death because it reveals that I, born in 1964, never met Loquito. What's more, I always felt—as absurd and vain as this feeling was—that El Loquito had died so that I could exist. That's why—with due respect to the obvious differences—I've usurped here the title of an essay by Maurice Blanchot about a friend he never met but with whom he had everything in common. *Michel Foucault as I Imagine Him*, the book is called. There he conveys a deep admiration and affection that did not require physical contact. The book gives us a sense of the survivor's unease.

How much is there in me of that imagined older brother who gave up his fantasy life so that I could have a real one?

Almost every day for two decades, I have walked down the Rambla in Barcelona. There you have no choice but to encounter more than a million pedestrians a day, from all over the world and from every walk of life. Sometimes I slip into this city's side streets to escape the human traffic, the bustle of tourists, and then I stop to flip through records or books, to have a drink, to watch the Mediterranean women.

And there are days when I lose myself in a different way, imagining jokes or bits of mischief that would definitively not translate well into my life here. I walk on, laughing to myself, one hand resting on my stomach inside my jacket, cross-eyed, wearing a hat made of newspaper on my head.

THE IMPENDING BLOW
2014

I

When citizens of Berlin tear down their Wall, Latin America has an advantage over Eastern Europe when it comes to certain dilemmas that emerge from the collapse. For starters, they already know what the failure of the Left and the dismantling of a polarized world—or their polarized world, at least—looks like. They know what it means to transition to democracy and how the cocktail of shock therapy and neoliberalism is shaken. And because of this, they even know what it means to destroy, every day, a three-thousand-kilometer wall that marks the border— The Border—with the United States.

These advantages mean they proceed with certain caution when it comes to gauging the impact of the Soviet Empire's collapse on this world across the Atlantic that Octavio Paz once called "the extreme West." (The West in extremis, more like.)

You only need to think of the two revolutions that had established power by 1989: Socialist Cuba and Sandinista Nicaragua. OK, so the latter—which was not governed according to the Soviet model—collapsed following elections and a civil war, three months after the Berlin Wall came down. Cuba, though, which was structurally integrated into the imploding galaxy, managed to survive as a communist state alongside China, Vietnam, and North Korea.

Latin America was no stranger to the Cold War: from the Missile Crisis in the Caribbean in the 1960s to the so-called low-intensity

conflict in Central America in the eighties, by way of the dictator-ships that took hold in the Southern Cone in the seventies, the battle between communism and capitalism (or, perhaps more accurately, between the United States and the Soviet Union) for global hegemony also played out in that region. But even taking this nexus into account, it would be wrong to say that communism's hecatomb had a mere knock-on effect in those regions.

II

Peculiarities visible in politics are even more pronounced in cul-ture. November 9, 1989, found some Latin American intellectuals frantically trying to revive their canons, more worried about North-South relations than about the East-West conflict, and much more distressed by the crisis of modernity than by the crisis of communism. Whether they're talking about traditional contro-versies or the challenges posed by brand-new globalization, their mosaic of concerns is matched by the variety of criticism rolled out to tackle it.

What was being discussed in Latin America in 1989? Well . . . everything from the particularities of postmodernity to the repositioning of (post)colonialism. From state repression to societal violence. From the validity of utopias to the effects of an anomalous modernity. From revision of identity determinism to inquiry into the status of tradition in contemporary society. In the West Indies, these arguments are focused on going beyond the variations on Caliban's tale that have monopolized depictions of island life.

To tackle these challenges, it wasn't enough to repeat the usual stance vis-à-vis the old colonial metropolises or US imperialism (important though it was to keep them in mind). That's where they diverge from the binary thinking of the 1960s, which, under

the impact of the Cuban Revolution, had relied on liberation theology, dependency theory, and the aesthetics of the boom.

Which West took pleasure in proclaiming (and profiting from) its decadence? There was Nelly Richard to vindicate "the crisis of the original and the revenge of the copy." Or Roger Bartra to uncover the imaginary networks of political power that fed Mexican nationalism. Or Antonio Benítez-Rojo to emphasize a global Caribbean overspilling its own geography.

Alberto Flores Galindo recovered the Andean utopia on his journey to the origin of violence in Peru, while Aníbal Quijano vindicated that utopia as a suitable way out, a way "of ceasing to be what we have never been."

Latin American culture had its own walls to pull down if it wanted to scale a different ladder; and it became clear that the great wall of stereotypes must be destroyed if we want to rid ourselves of the colonizing gaze—both our own and that of others.

III

It was 1989, the year of *Magiciens de la terre*, an art exhibition in the Centre Pompidou that ran until August 28. That was less than three months before the communist world began to be dismantled, but it would be absurd to establish a cause-and-effect relationship between the end of an exhibition and the end of an empire. Besides, despite the inclusion of Cildo Meireles and José Bedia, *Magiciens* . . . wasn't even about Latin America. That said, we cannot deny its value as an inauguration or the way it spawned later projects. *Les Demons des anges* (1989), *Kuba o.k.* (1990), and *Cocido y crudo* (1994) were three of the first exhibitions to strengthen that mode, with all its nuances, good intentions, and unalterable distribution of roles. There you'll find peripheral (or subaltern) culture being explained by First World institutions and

curators. You'll find a mix of redemptive enthusiasm, criticism of the center by the center itself, the exaltation of irrationalism, and a repertoire of exotic fantasies that Edward Said had already dealt with in *Orientalism* and *Culture and Imperialism*. And you'll also find standardization, which, in the post-Berlin world, elided Latin America with Eastern Europe, Asia, and Africa, according to post-colonial codes.

The year 1989 establishes a link between the advent of post-communism and the apogee of postcolonialism. Among other things, because, although communism had been defeated, it was certainly not dead and buried. It was colonized by a capitalism that was kind enough to recycle its iconographic assets, its plutonium, its gas, its oil, and its authoritarianism.

The Latin America, in all its diversity, that welcomed the year 1989 was soon smoothed out by postcolonial standardization that forced it into overtly and covertly ethnocentric canons. It was turned into an immense ready-made product with a renewed emphasis on the folkloric, and the continent was allocated as a cultural reserve for the revitalization of a West that has settled into the end of History. This isn't to deny that Latin American culture was inserted into global culture. Rather, it must be recognized that this insertion came at the cost of a reduction in Latin America's own diversity and a frequent denial of its ability to imagine itself.

IV

Unlike colonialism or neocolonialism, postcolonialism has been presented as a correction, as a positive affirmation of others. For this to happen, both subject and action had to be removed from the proceedings: Anyone can claim to be a specialist in postcolonial studies, but people think twice about calling themselves

postcolonialists. And anyone can show off their mastery of a subject, but nobody would talk about "postcolonizing" it.

Criticism of this paradox has not been well received in recent years. Largely because of the deplorable argument that it was all done in the name of subaltern cultures, or of the emancipation of people classed as ethnic subjects . . .

Now that they are becoming less and less defensible, perhaps it's time to strike a blow to those strategies, just as we struck a blow to the wall in Berlin twenty-five years ago.

APOTHEOSIS NOW
2015

I

"The Homeland or Death"; "The Maximum Leader"; "With the Revolution, Everything; Against the Revolution, Nothing"; "The Future Belongs Entirely to Socialism"; "The Greatest Enemy of Humanity"; "The Most Beautiful Land," according to Columbus; "The First Free Territory in America," according to Fidel . . .

These absolutes have not disappeared from propaganda or attempts at persuasion, from the dreams or nightmares of Cuban people, but it's good to know that, for some years now, this Caribbean island has been slowly abandoning Life in Capital Letters, along with the grandiloquent all-or-nothing speeches that have characterized its politics, culture, and language.

At first, maximalism took its lead, as it must, from official discourse, but it wasn't long before the politics of exaltation—including a curious personality cult around Fidel Castro that got turned on its head—spread to parts of the opposition and the exile community. For those adept at leading a Life in Capital Letters, Cuba seemed to be limited to whatever emanated from the Plaza de la Revolución or the White House, two fortresses charged with broadcasting military marches that drowned out the slightest whisper that wasn't part of the Cold War soundtrack.

Whether from critics or members of the claque, these sound bites always had one thing in common, which was that they paid as little attention as possible to the regular Cubans they claimed

to represent, those *individuals*—and to call them that is already
a sign of their worth—struggling to evolve as best their circum-
stances allowed. The silent society that spent all those years
trying to dignify survival and relax the strict dictionary that
defined them either as mere extras in a theme park called Revo-
lution or else as perfect beings programmed in the laboratories of
the New Man.

Something of this gave up the ghost, by official decree, on
December 17, 2014, the day many Cubans venerate Babalú-Ayé (or
Saint Lazarus, if you're Catholic). At noon that day, Barack Obama
and Raúl Castro set aside their respective monologues and rehearsed
a duet, albeit not quite in tune, to notify the world simultaneously
that diplomatic relations were imminent. A small step in the history
of mankind but a giant leap in the history of equalization.

But the schedule in which elections were to be called in Cuba,
followed by an end to the US embargo and culminating in the
establishment of embassies, was destroyed the moment they
decided to put the cart before the horse.

That December 17 will perhaps go down in history as the day
when Cuba officially began to operate in lowercase. Ground zero
from which an island trapped—for better or worse—in its own
exceptionality set off on the path that would place it closer to the
norm than to something epic.

It was agreed that Cuba would accede to the mainstream world
of globalization, Market without Democracy, and the universal-
ization of a Chinese model that long ago ceased to be exclusively
Chinese, for their eyes only.

In Cuba, "the Enemy" became "the neighbor." In the United
States, a country on the list of state sponsors of terrorism
became a viable economic partner for the immediate future. The
journalist Carlos Manuel Álvarez described this semantic trans-
formation in an article published in *Malpensante*. A text driven

by the hope that a change in the official discourse would, "with its power, whatever it inspires in us," sooner or later inevitably change the language of ordinary Cubans too. For Álvarez, once they'd got past that warlike encyclopedia, Cubans would become, precisely, a "tribe that buries its dialect."

The New Deal between Cuba and the United States was celebrated almost everywhere as the definitive burial of the Cold War. But we could think of it as the opposite: the two contenders, rather than burying the Cold War, decided to recover its effectiveness in dealing with a chaotic world. Faced with instability in Venezuela, the spread of drug trafficking, failed states, the European crisis, the situation in Ukraine, terrorism, the threat of Islamic State, and the rise of China—not to mention the falling price of oil—a return to the diplomacy of the bipolar era might have its advantages in dealing with a geopolitics that's lost its way.

II

This waning of Life in Capital Letters can be read, too, as an erosion of the monopoly of the State over people's lives; a wearing away of control over information, entertainment, food, education, health care, and the possibility of travel. A tide of television packages, restaurants, private revision tutors, street vendors, nurses, trips to foreign countries, and the buying and selling of almost everything imaginable have managed to invigorate the country and shake up the rituals of everyday life. Thanks to or despite the State, Cuba is treading further along the path of other Caribbean countries that underpin their social welfare systems with the semi-informal side of an increasingly thriving private sector (remember, we are talking about the Latin American country with the highest level of state involvement in its economy or indeed in any aspect of life).

Just think of the internet: broadband-less and under state control. Still, a perversion of networking has become habitual there, whether for business, surfing the web, or downloading files, that allows people to furnish themselves with a freedom the State does not want to grant but cannot impede (at least not completely).

That famous December 17, when the country was euphoric at The News—suddenly, nothing was more important—I took a taxi with several strangers through the Havana night. The taxi driver blasted us mercilessly with high-karat reggaeton until someone in the back let out a: "Come on, brother, turn that shit off and let's have FM, it's practically a local station these days." This was just one of the many jokes during a time when, faced with any kind of mishap, people would roll out the sarcastic refrain: "Chill, Obama's on it." They were jokes, of course, but also expressions of relief felt by a country that had for decades been subject to a continuous demand for sacrifice, and which now saw an escape valve without knowing exactly where it led.

Around that same date, in the open-air political forum the country had become, someone suggested a graffiti slogan with two possible variations. One: "Down with Raúl, long live Fidel." The other, the opposite: "Long live Raúl, down with Fidel." Like the jokes about Obama, or about an imminent US invasion—unarmed this time—that would apparently resolve everyone's problems, the graffiti slogan was evidently an exaggeration. But there was also a seed of truth in its perception of the difference between reformist Raúlism and a revolutionary Fidelism. Whatever the Revolution had been, and whatever remained of it, it had gone into repair, to the extent that the trovador Silvio Rodríguez proposed deleting the *R* and opting instead for Evolution in order to save the original project.

III

In any case, the "Raúlist reforms"—as they are called even at an official level—are not designed to change the political model. Their immediate objective is to adjust the system by connecting it with the market economy, to relax a Cold War–era migration policy, to reestablish diplomatic ties with the United States and to change the emphasis of the official discourse from the importance of sacrifice to the benefits of work. That is, to tune Cuban socialism to the sound of the twenty-first century without compromising the upper echelons of power or allowing what is tolerated in the economic sphere to spread to the political sphere. Previously, a version of the Soviet model was preferred; this is a version of the Chinese model.

But in a country ruled by reforms, the opposite is not counterrevolution but rather counterreform. And this detail is key to understanding the critical spectrum generated by the new measures. It is a broad and contradictory spectrum that includes, of course, government bureaucracy, but also the ultraright opposition and exile community, who have always banked on stagnation—on things staying the same. There is also the so-called moderate opposition, which sees in these changes the possibility of a transition agreed upon with the state. Moreover, we would now have to include much of the dissident Left, interested in debating both the political model and the way the economic model is exacerbating inequality. Criticism has been swift, even from the art world, which is usually sheltered by a protectionist bubble.

The best-known case was Tania Bruguera's thwarted performance in the Plaza de la Revolución. A critique that attracted less media fanfare is the graffiti artist El Sexto's attempt to set two pigs named Fidel and Raúl racing through Havana. Both artists were arrested. In another field, the theorist Desiderio Navarro campaigned against

sexist and racist adverts in the new economy, while the artists José Ángel Toirac and Reynier Leyva Novo have compared leaders' current practices with the original Revolution-era discourse. If the sessions of Cuban's parliament are unbearable to listen to, the improvised debate in homes, in stalls, and on street corners is turning the island into an unofficial agora where people debate everything from the best way to get out of or stay in the country to the latest frivolity of the new jet-set class, from the inflated prices of non-rationed food to the latest television series. It doesn't matter whether they saw it on a clandestine "Paquete Semanal" ("Weekly Package," a private alternative that allows you to get around the lack of broadband and to supplement state television programming) or on some official program such as *Vivir del cuento* (Live by the story), which takes stock of the contradictions in a country where facilitating and hindering change are no longer associated with clear political objectives. (There are revolutionaries who want to change things, and then there are the nouveaux riches, with all their capitalist ideology and shuffling around of money, who will make the biggest profits if everything remains exactly the way it is.)

The counterreform movement, on the other hand, has also had some incomprehensible moments, which shows that intransigence is not the exclusive preserve of bureaucracy. It's hard to understand why certain representatives of the exile community, which has traditionally emphasized the importance of the United States to Cuban politics, have not heralded the successful reestablishment of diplomatic relations. Or indeed why no sociologist has warned of the growing "miamification" Cuba is experiencing. You can spot it a mile off: from the music played in hotels to family investments in new businesses, as well as language and popular culture. For less than this, Fidel Castro would have declared it one of his famous transformations of Misfortune into Victory and passed the hot potato to the enemy.

IV

Capitalism is inarguably today's universal system (even North Korea is exploring its own restricted version of the Chinese model). And there is no doubt, either, that capitalism works only for capitalists. Having destroyed the fantasy of the self-made man who could rise above the stigma of his inherited poverty, this selective capitalism is embedded in the elite classes and certain governments who legislate for them (rather than for all capitalists) as a reward for their loyalty (rather than their competitiveness). This capitalism contains little of the old liberalism, nor of the spirit of Adam Smith in *The Wealth of Nations*. Selective capitalism is rooted in the establishment of dictatorships in the Southern Cone and in Deng Xiaoping's communist China, models that David Harvey identified as the origins of neoliberalism. Another important chapter in the story of selective capitalism tells of the transformation of communist societies, with their shock therapies and the emergence of new oligarchs from the ruins of the old regime. A third chapter can be found in the United Arab Emirates, where the marriage between oil and monarchy continues to be seductive to the West.

The United States, Europe, Russia, and China are increasingly inclined toward this kind of members-only capitalism under which the State functions as operations manager, as mediator, or as mere subordinate. In this model, which has various incarnations, a capitalist isn't evil just by virtue of being a capitalist, but because they are not supportive enough of government policies. And vice versa: for these ultraliberals, governments—even despotic dictatorships—are not evil so long as they allow them to operate as they please. Some theoreticians talk of "patrimonial capitalism," others of "one percent capitalism," and still others of "speculative capitalism." I like the Nicaraguan term, "a piñata"

(a word used in Nicaragua to describe a landgrab scheme by the Sandinista government in 1990) because only those who accept the terms are allowed to pull the strings of profit.

Cuba today is no stranger to these currents, which can explain why it's so hard to grow this model among Cubans and, on the contrary, why it fits so easily into the world beyond the island's borders. That said, we can't expect much future from an economy leaning toward services and entertainment, with tourism extolled as the latest mutation of the old monoculture of underdevelopment, while critical thinking and what is now known as the "knowledge society" are avoided. (It's easy to open a hairdresser, but practically impossible to imagine starting a publishing house; and it's much more acceptable for an artist to address the issues I'm discussing here than for an essayist to write about them.)

This makes me think of what José Martí famously said to Máximo Gómez, which to this day has been like a Sword of Damocles hanging over Cuba's failed democracy: "A nation is not founded, General, as a military camp is ruled." In the face of the new economy, the phrase is worth updating with a warning: a nation is not refounded either, General, as a new paladar is opened."

V

In her new novel, *La mucama de Omicunlé* (*Tentacle*, translated by Achy Obejas), the Dominican writer Rita Indiana depicts a Caribbean dystopia in which the great, timeless themes of Alejo Carpentier, Lydia Cabrera, Aimé Césaire, and Antonio Benítez-Rojo are updated in a plot that moves between the Dominican Republic, Puerto Rico, and Cuba (with Haiti always shaking up the future like the unburied zombie of a revolution gone catastrophically wrong). The book envisages, by 2024, the drifting of certain neoliberal states into corruption and the bifurcation of certain

Bolivarian states into totalitarianism. Needless to say, each of them has accepted their role in the script, their slice of the cake, though they have not been able to prevent, unlike in the 1962 Missile Crisis, a nuclear disaster.

This disturbing premonition is repeated by Jorge Enrique Lage, born, like Indiana, in Cuba in the seventies, and whose dystopia depicts a Big Bang from which Cuba emerges with old slogans and new mafias, old loyalties and new tribes, united by a highway leading nowhere. The painter Alejandro Campins, meanwhile, prefers to travel to places where revolutionary gestures were made and depict them as they are today, producing paintings closer to Andrei Tarkovsky's *Stalker* than Raúl Martínez's revolutionary pop art. Looking at his *Avalancha* (Avalanche) series, we do not know whether our present is rushing into these formerly sacred spaces, or whether the landscapes themselves are hurtling toward us, further complicating our already uncertain present.

These works portray an overview of a country that, its Utopia not yet complete, has devoted itself to avoiding the Apocalypse, to avoiding all the tensions hanging over this mix of post-communist zones and socialist regime, authoritarianism and showbiz culture, single-party system and tourist destination, center of scientific research and family remittances, state internet control and Netflix in the Paquete Semanal, Chinese model and Cuban flavor . . .

Today the transition from pre-democracy to post-democracy is a real possibility, something perfectly endorsed by world order. And the truth is that liberal manuals don't say much more than that; it's important to recognize that, among all the empty words, among all those capital letters that have shrunk, Democracy has an important place. Like clay plant pots: beautiful but fragile, immovable but hollow.

Just as communism proved it could not last forever, there are not many reasons—except for inertia—to trust in the longevity

of a leaky capitalism, reflected in those Caribbean futurisms, mirrors that can erase any suggestion of immortality.

Right now, it doesn't matter whether socialists insist that the transition in Cuba *has already happened* or liberals that it is *yet to come*. What neither of them can avoid is that their solutions are worn thin, and that their boastful claims of a magic potion for the future are not remotely credible.

The Utopia generation has run out of time. And the Apocalypse generation, those children of the Revolution who came of age with the fall of the Berlin Wall, never had any space. However, the Apotheosis generation, the one that has come of age in the twenty-first century, has the dimensions of both time and space available. Let's hope they discover the elusive formula that will allow them to build, despite the rising tide of both Cuba and the world, a country where social justice and democracy are not antonyms.

In the meantime—and now that "cuentapropismo" or self-employment is allowed—many Cubans are eking out their own freedom as best they can, waiting for the experiments looming over them to yield some results that might better their lives.

ICONOCRACY
2011–2016

In February 1957, Herbert Matthews published the first global report on Fidel Castro in the *New York Times*. He wrote the article in the Sierra Maestra, during the guerrilla war against Batista, and it made him both a pioneer of Western fascination with the Cuban Revolution and a facilitator of the young comandante's global debut. Such was Matthews's impact that a book by Anthony DePalma came to describe him as "the man who invented Fidel Castro."

In reality, it was the other way around: the report and the accompanying photographs chimed perfectly with Castro's plans; from the beginning, he had a two-pronged approach to strategy. First, history ("History Will Absolve Me" was his legal defense, his political program, and his slogan). Second, image, particularly his own. From day one of his project, Fidel was careful to light one candle for the man and another for the myth. He was as focused on heroic deeds as he was on his own facial expressions.

As far as the world was concerned, Castro never needed a spin doctor. That side of things was always well covered: whether by Cartier-Bresson ("the eye of the century") or Barbara Walters; by the *Times* or CNN. In Hollywood alone, Fidel Castro or his shadow have circled the plots of Carol Reed, Alfred Hitchcock, Richard Lester, Francis Ford Coppola, and Sydney Pollack. Jack Palance and Demián Bichir have played him on the big screen. Robert Redford, Kevin Costner, Steven Spielberg, and Sean Penn have acknowledged at least their curiosity, if not their admiration, for the character.

Oliver Stone went further, comparing Castro to Alexander the Great and glorifying him through three documentaries in which he (Castro, not Stone) starred. When John Paul II died, Josep Ramoneda said of the media: "One of their own has died"; the same can be said of Castro's relationship with the mecca of cinema.

Castro hasn't neglected his Cuban-facing profile either. For this purpose, he recruited a large and well-qualified troop of what we might call battle photographers: Enrique Meneses, Raúl Corrales, Roberto Salas, Liborio Noval, Alberto Korda . . . From day one, Fidel Castro was to be both the news and the one breaking it. He would be the actor, the scriptwriter, and the critic of a long film about himself with which he colonized the story of an entire country. We mustn't forget that the Cuban Revolution was the first revolution of its kind to make extensive use of television, and which, unlike other communist countries, did not need gigantic statues to spread its official iconography. That was what photography was for—much more modern, portable, and, above all, impossible to tear down, should the wish arise.

Fortunately, visual culture can also be critical, and just as images can be manufactured, they can also enact the strange vengeance of being digested and then regurgitated in a different, unexpected guise. Contemporary artists, for example, have not treated the Comandante with the same acquiescence as his photographers. Several have refused to take part in his hagiography, preferring to capture moments when acting turned to overacting, a portrait into a caricature, vigor into decrepitude, politics into performance—names such as Tomás Esson, Joel Rojas, José Ángel Toirac, Eduardo Ponjuán, René Francisco, and Arte Calle come to mind. And it should also be added that these critical portrayals were done *right there*, in Cuba, despite all the consequences. More recently, the Spanish artist Eugenio Merino has set up a

sculpture of a zombie Fidel Castro, a video game, *Call of Duty: Black Ops*, has incited players to kill him, and Homer Simpson got caught up with the Comandante in order to settle a debt with the US Treasury . . .

One way or another, the Cuban Revolution lies at the origin of what we now accept as the Age of the Image. And for this very reason, it's perfectly reasonable that this era should have been cause for concern for several authors—Giorgio Agamben, Miguel Morey, Joan Fontcuberta, and Paul Virilio—particularly about the dangers that go hand in hand with fascination, a word that has more than just a linguistic root in common with fascism.

There is no image without imagination. By controlling both, Fidel Castro managed for ten decades to dominate Cuban life so absolutely that hardly anyone escaped his omnipresence unscathed.

Surviving that domination involves filtering the bank of images he has left for posterity; but, above all, it means ruthlessly revising the imaginary constructed by those images. The successful execution of this task will, to a large extent, determine the success of any future political project in Cuba.

THE BANQUET OF
CONSEQUENCES
2017

I

"Sooner or later everyone sits down to a banquet of conse-
quences," wrote Robert Louis Stevenson, island fanatic. And that
is what is happening, right now, on the island of Cuba: a banquet
of consequences. An endless waterfall—no time to get your head
above water—of visits, from artists as renowned as Frank Stella,
a US president (Barack Obama), a professional baseball team (the
Tampa Bay Rays), a famous rock band (the Rolling Stones), and
Karl Lagerfeld, spearheading Chanel's Cuban chapter.

Welcome, then, to the long march, whose spectacles are proof
of change in this country better disposed toward the consump-
tion of transformation than the discussion of it. As though it
were necessary to sacrifice the causes of events in exchange for
enjoying their consequences.

Let's go back to when the Revolution became famous. It was the
1960s and Cuba was full of intellectuals from all over the world,
ever ready to give theoretical support to the so-called Cuban
way: a socialism that was green ("like the palm trees," according
to Fidel), rather than red, that was Latin American rather than
Soviet, and that fed the fantasies of the West.

Today, however, in this Cuba of consequences, entertainment
is enough to set the tone. With its touch of glamor, its carefree
key, and reggaeton marking the rhythm of a new life from one
party to the next. Where once there was Sartre, today we have

Beyoncé; where once there was Max Aub, now we have Paris Hilton. The British quota once fulfilled by Graham Greene has been passed on to the Rolling Stones, and the record turnouts at the Great Leader's speeches are now broken by the electronic sounds of Major Lazer.

Within this catharsis of controlled hedonism, even a politically important trip like Obama's was filtered through the country's most famous comedian, who struck up a conversation with the US president that was full of double meanings, absurd jokes, and unofficial truths.

The ping-pong diplomacy between the Chinese and the US in the Nixon-Mao era will go down in history as a solemn exercise beside this meeting between Obama and Pánfilo. A meeting, by the way, which left government protocol, the opposition, and the exile community all completely bewildered.

So many millions of dollars earmarked by the United States to promote democracy in Cuba, and it turns out all that was needed was a simple, rudimentary video of their president playing dominoes with an eccentric character who purports to understand nothing so that his viewers will understand everything.

In this Cuba of consequences, no one imagines Paris Hilton or Mick Jagger leading a debate about the political model. Neither do the authorities seem remotely interested in ideological discussion in a country that swings between illuminating the Bolivarian model and remaining in the shadow of the Chinese one.

After Obama, what next? Many people asked themselves this question after his visit, both on the left and the right, both on and off the island. Evidently, survival might mean continuity—to the extent that there can be continuity with a government full of octogenarians—but people are also convinced things cannot continue as they have. And not only because of the semi-opening up of services—paladares, gyms, bars—but for the impact of the new

economy on areas hitherto sacred to Cuban socialism—education, culture, health—which are starting to be underpinned by private initiatives that would have been unthinkable in other times.

The problem, in any case, is not just change but also the direction of change. This is the tightrope the country is precariously walking, a country in which most people are not in favor of shock therapy.

Today's Cubans want money, but they also want time. They want their own businesses—mostly family rather than strictly private ones—but also to maintain networks of solidarity that continue to beat amid all the everyday uncertainty.

II

In this Cuba of consequences, anything that moves can be a taxi and anything static can be a room for rent. (Or a restaurant, a bar, a hairdresser, a gym, a clandestine shop.) This is the new face of a private economy that is growing in real time, and in online adverts, before everyone's eyes.

Welcome to the "rudimentary" accumulation of capital. It has its own laws, its own traps, and its own emerging classes, though it's still far from any kind of standardized capitalism (if such a thing exists).

This new capital has its own embryonic symbology of money, and a mix of agitprop and advertising that's overtaking the old icono-graphic pact between Che Guevara and US Cadillacs—between an indestructible icon that kept mythology alive and the indestruc-tible cars that kept everyday life moving. So there is also room for a connection between the practitioners of revolutionary tourism and the last reserve of old combatants who now live by renting out their homes, with their own epic tales included in the price.

This is what I'm thinking about one night in March of 2016, as I look out at the Malecón. I'm in a building where almost all

the owners rent to tourists, sitting on the balcony of a veteran diplomat who has mentored several generations of Cubans in the foreign service. It is his birthday and, at some point during the evening, the party troops disperse.

The old guard moves on to talking about politics; their children, about business. One group is rhetorical; the other is pragmatic. One is history and the other is geography: a simple marking of territory.

It's a few days before US president Barack Obama's visit. At some point during the party, someone receives a government text message directed at all those who make a living from renting out their property.

It's . . . an anti-terrorist order.

A warning to be on high alert around possible tenants from Arab countries, as well as from Israel. The message communicates a tropical version of the Axis of Evil in which the usual native suspects will sooner or later find their place.

"They're making sure Havana doesn't become the new Dallas," says one of the younger members of our little banquet, in a clear allusion to JFK's assassination. "Don't worry, my love. There was no state security in Dallas," her boyfriend responds. Evidently the package Obama brings with him involves the application of the Patriot Act in Cuba. Preventative detention will no longer be exclusive to the Soviet inheritance, but a current, very US American practice.

Private Cuban initiative will be anti-terrorist or it will not be.

III

A few weeks later, my mother looks out of her window to find the street has been taken over. She doesn't dare go outside, not understanding the neighbors' explanation for the growing chaos down below: "They're filming *Fast & Furious* in Havana."

In Cuba today, everything is considered a turning point, is seen as an event, and is endowed with the transcendence needed to mark a before and after in the life of the country. It could have geopolitical reach, or cultural, or simply festive; in this way, Obama's visit is just as important as the opening of Galleria Continua . . .

Fast & Furious is no exception. Although, as far as the neighborhood is concerned, what's important is that at this time in the morning there is usually nobody in the street, whereas now people are having to negotiate dozens of motorbikes, ultrafast cars, trucks, top-of-the-range convertible Almendrones, vulgar-looking men smelling of Prada, models, paparazzi, security, extras . . . and endless curious onlookers for whom all of this is what José Lezama Lima would call an "unmentionable party."

Still dubious about what she considers to be a full scale "occupation" of the neighborhood, my mother arrives at the conclusion that we are living through an "American invasion."

And she's not wrong.

With a couple of exceptions, such as the documentary *Cuban Chrome* (about all the old cars rolling around Havana), we haven't had a US production of this scale on the island for more than half a century. But now, among the many business opportunities the US is seeking to exploit in Cuba is the chance to turn the country into an immense Hollywood set; a virgin backdrop against which their unlikely superheroes can race around fast and furious.

This isn't to say that Cuba has been absent from the plots of US films—just look at Coppola and Pollack—but due to the embargo or bureaucracy, the country has tended to be re-created in the Dominican Republic or Puerto Rico. Cuba has also had a presence in television series like *The Agency*, *Law & Order*, *CSI*, *The Simpsons*, *House*, and *Castle*. In fact, those productions offer us a clue to the stereotypes coming Cuba's way. It doesn't matter whether the show is about assassinating Fidel Castro at the UN or the

stolen trillion dollars that gets Homer Simpson tangled up with the FBI and lands him in Havana, or—pushing things to the point of absurdity now—the writer-detective Castle trying to solve the case of a baseball player murdered in Manhattan surrounded by a swathe of suspicious Cubans speaking . . . Taíno!

Anyway . . .

For a long time, Cuba has been a country where people go—left wing or right wing, tourists or entrepreneurs—not to discover a reality, but to confirm a script. So its paradoxes are pushed into the background, with Cubans condemned to being mere extras crushed by the weight of previous judgments, of prejudices.

The irony is that while Cuban filmmakers have for years been fighting for a new cinema law, when it comes to a US mega production like *Fast & Furious* everything rolls smoothly, to use an appropriate metaphor. Trapped between national sluggishness and transnational speed, Cuban filmmakers continue to clamor for independence. And no matter how they try to make the most of things, it's logical that they should fear the torrent unleashed by the diplomatic détente with the US, this heyday of television series and the financial need that forces them to participate while also carefully managing their subordinate role in these events.

Their struggle is not only for production independence but also for freedom of speech, so they can engage with the mixture of tourism and diplomatic thawing that is already fueling a narrative in which even ideology is on its way to becoming yet another chapter of tropicalism.

That tension, on the other hand, reflects the complexity of the opening up of relations with the United States, the delicate balance it involves.

Practically speaking, this industry, capable of generating profit, updating technology, and offering employment, is seductive (and even necessary). Culturally speaking, though, as soon as this new

era began, we headed back to those picturesque scenes from *Our Man in Havana* in which Cubans, maracas in hand, provided rhythm for the imperturbable avalanche of neocolonialism.

IV

The Seventh Congress of the Communist Party of Cuba concluded at almost the same time as the filming of *Fast & Furious*. And it did so in the grip of another vintage fetish: unanimity. Meanwhile, ruminating on what was discussed there, and above all what was *not* discussed, a group of old revolutionaries persists in their favorite hobby: putting the country to rights from a bar in Havana.

It's a dwindling group, shaken by the casualties age has inflicted on them. (My father used to tell them: "I'm in the queue," until his turn finally came round, and he left both life and the group behind.)

They were all involved in the uprising against Batista, and some of them have been through several wars. Almost all of them have children or grandchildren in Miami. Those whose houses are presentable enough manage to scrape by in their retirement by renting out to tourists. Trying to recycle themselves for new times. Without adapting entirely, without giving up entirely, just criticizing everything. (Or almost everything, "which is not identical, but it is the same," as the trova singer Silvio Rodríguez would say.) Their debates on "the topic" always involve plenty of rum, and an ambulance on standby in case somebody has one too many.

In Cuba there is a brand of rum that treads a fine line between acceptable and dangerous. It's called Planchao, and it costs one Cuban convertible peso (about one US dollar). Connoisseurs of white spirits guarantee those individual white Tetra Brik cartons contain something good (though they might not always want to admit they've tried it). The problem is that some of the veterans

in this bar are, economically speaking, under even the Planchao waterline. And the combination of age and the strongest spirits out there—a cocktail of hard liquor and soft currency—often lands them in a tricky situation.

The men's agitation also arises from their strident debates about economic reform, Obama's shrewdness, the absence of a tangible program for the future, or the fact that new inequalities have situated them—"we're the ones putting our necks on the line, for *this*"—in a precarious position, perhaps, even worse, at risk of being totally forgotten.

In their twilight years, these graybeards ruminate on a revolution that for their grandchildren is nothing but an echo of the past. They are still waiting for their like-minded counterparts in power to give some sign of the political model, but they only ever receive hints of economic reforms. They cling to those times when Cuba proclaimed itself the first free territory in America, but on the TV in the bar the news bulletins keep proposing the island as the Caribbean's best foreign-investment opportunity.

As you approach the bar where the veterans are drowning themselves in their alcoholic quarrels, you'll find the usual line of taxis waiting to pick up tourists. A multicolored queue including, of course, the US Almendron, the Chinese Geely, and an enormous Soviet Chaika.

In Cuba, an outlandish car is hardly news. But that Soviet limousine takes extravagance to new extremes.

There are actually ten Chaikas for hire in circulation in Havana these days. The fleet was a gift from Soviet high command to guarantee Fidel Castro's safe movement. (No other taxi can boast such pedigree.) Get in one and the driver will happily explain the workings of this communist limo, which still has space for a radio, seats for escorts, and compartments for ancillary weapons. As for doing business in it, it's not much different to other taxis in

Cuba's new economic regime. "Every day I have to pay the company thirty Cuban convertible pesos [around thirty dollars]," the driver tells us.

Twenty-seven, actually, to be exact.

Could there be a better illustration of how the remnants of socialism are recycled in these new times? Could anything be clearer than communism using the Comandante's own fleet of cars to make itself profitable under the imperatives of economic reform?

If there was any doubt about this symbiosis, it dissipates when the Chaika reaches our destination: this sperm whale of Cuban taxis leaves us at the door of TaBarish, a "Soviet" bar, full of communist motifs, where you can order caviar, vodka, soup, or pickles while surrounded by old copies of *Pravda* newspaper mounted on the walls. The combination of Yuri Gagarin smiling down at you from their pages and a red flag—hammer, sickle, and all—creates an aesthetic that mixes Soviet nostalgia with the new Cuban reality.

The TaBarish makes business out of old communism, or at least tries to. And people parade through, from Russians to Cubans who studied in the Soviet Union (there were tens of thousands of them), just as they do at Nazdarovie, because TaBarish isn't even the only Soviet establishment to have opened with the advent of private initiative. Among the bar's innumerable decorations are of course the famous matryoshkas, "dressed up" for the occasion with the faces of Lenin, Stalin, Nikita, Brezhnev, and Gorbachev. Putin is there too, which for me is a troubling reminder that the end of the Cold War was a pact between old communists and new oligarchs.

Since the Revolution began, Cuban socialism has been conquering the old emblems of capitalism at top speed. It started with the Hilton Hotel, which was rebaptized La Habana Libre Hotel, where Fidel Castro set up camp. Later, there was a headlong rush for old US cars, which were still battling away with their built-in Soviet engines. Along the way, barracks were converted

into schools, exclusive clubs transformed into social clubs, as well as cabarets, chic restaurants, hotels . . .

Now, we can see the opposite happening: at the heart of socialism's emblems, the commercial relationships of new Cuban capital are beating ever faster.

Look no further than the Committees for the Defense of the Revolution (CDR), which today are also dedicated to policing and guaranteeing private rental properties. Or consider how police language—"pasa que el capitán te quiere ver" (go on in, the captain wants to see you), "tíramelo por la planta" (run it through the system for me), "relájate y coopera" (relax and cooperate)—has been integrated into the refrains of everyday life. Not to mention the widespread use of a mobile app that allows anyone to find out the name, address, and date of birth of the person calling them. (And yet no one is scandalized by the use and abuse of Big Data at a national level, confirming that private economy and the elimination of privacy are perfectly compatible behemoths.)

V

In January 2016, the press Arte y Literatura published *1984*. In a country that has been described—whether because of its geography or its ideology, because it's an island or because it had a revolution—as a utopia, George Orwell's dystopian novel has all the ingredients of a big-hit publication.

Of course, there was no shortage of people pointing out how belated the publication of this masterpiece was. There were also those who, jumping on the Orwell bandwagon, demanded *1984* be followed by *Animal Farm*, that dissection of Stalinism so thinly disguised as a generalized diatribe against abstract powers.

Those who reproach the missed encounter between Cuba and Orwell make a good point. That contentious writer whose

anti-Stalinism didn't stop him from fighting for the communist Partido Obrero de Unificación Marxista (POUM, or Workers' Party of Marxist Unification) during the Spanish Civil War, opposing British colonialism, or staunchly remaining on the "sinister side," as the Mexican poet López Pacheco liked to call the Left.

Nevertheless, *1984* arrived on the island at an appropriate moment.

Because the Cuba that finally welcomes the novel looks, increasingly, like a dystopia; ready to join the Orwell revival that has been spreading around the world since 2012 with reeditions, comics, and adverts for new film adaptations. (Hollywood has already decided it will do a new adaptation of the book, which has already seen versions directed by Rudolph Cartier, Michael Anderson, Michael Radford, and Terry Gilliam.)

In a way, we are all Orwellians. Even Cubans, who are, in addition, subjected to a cursed situation in which the absurd is all around, as Virgilio Piñera might say.

In that sense, *1984* offers us a survival manual, with built-in GPS, to help us find north in a world where market and democracy have long been on the verge of divorce.

It's not that this Orwellian Cuba has waved goodbye to Marxist discourse (or abandoned its conception of history in Leninist terms, with socialism as the final stop). But it has to confront the collapse of the Soviet empire that sustained it geopolitically and which has been explained—needless to say—as the death of utopia . . .

This being the case, Marx and Lenin are forced to coexist with Huxley and Orwell on every Cuban corner.

Under the designs for this utopia, the meaning of life was reduced to a future toward which we were inevitably headed. Under the dystopian model, however, we find that the future is already among us, that it happened "the other day," while we were busy planning for it.

So tomorrow is today, or any other day we are living through. A future that is neither perfect nor immutable. It's just *this*; it's what is happening right now, having taken us by surprise on this Caribbean island that is also, let's not forget, a scale model of the world (and of its crises).

VI

When a society collapses, we usually get hysteria rather than history. We get that vertigo that overwhelms us when we stand at the edge of a cliff. That said, the opposite reaction can also occur: we can live through a catastrophe with the appearance of utter calm. The eye of the storm, you might say. This was what happened in the final years of communism to a society built on the assumption that it would last forever.

Alexei Yurchak has called this reaction to shock "hypernormalization," in a book whose title makes his position clear: *Everything Was Forever, Until It Was No More: The Last Soviet Generation*. This volume, published in 2005, was incorporated ten years later into British writer and filmmaker Adam Curtis's documentary about the current crisis. In the documentary, Curtis examines the finite nature of the eternal beyond communism, taking in the fictitious world that postcapitalist financial bodies and large corporations have designed for us.

When we talk about the Cuban condition, it's important to note the sense of the eternal that has accompanied the political and economic life of this country. That connection between the immortal socialism of the future and the remnants of a capitalist past in which things (cars and fridges, houses and tunnels), too, were made to last "forever."

So it's not only a mode of governance or an economic model that is at stake here, but also awareness of a mortality heralding the finite nature of everything that has been built.

At this crossroads, our socialist side, wanting socialism to last forever, sustains that the transition has *already happened.* Meanwhile, our capitalist side, wanting liberalism to last forever, insists that the transition has *not yet taken place.* In the first scenario, Cuba improves, changes, evolves, but will never cross that bridge to join the countries in Eastern Europe. In the second, the transition hasn't even arrived yet, for the simple reason that we cannot talk about it until multiparty elections have been called or a market economy has been established on a large scale.

What some do not seem to see is perhaps simpler. It's not that transition isn't necessary, as some people claim. Nor is it that the transition hasn't yet begun, as others argue. It's that for a long time Cuba has known nothing but transition. And this transitive status has been understood as the most comfortable way to navigate an infinite limbo devoid of any future.

Whether brilliant or cruel, the product of logic or of superstition, longed for by the masses or concocted by tyrants, for centuries the future has drawn up the blueprints of history and relationships between people. It sowed power and encouraged resistance. The pyramids and the Great Wall of China were the future. The catapult and the steam engine were the future. Da Vinci and Verne were the future . . . So were a dog in space and a man on the moon. The future was the French Revolution and democracy. It was the Bolsheviks and Mao's Long March. The future belonged to the printing press and to free trade, to the steam engine and to communism.

But the future is also everything that didn't end up happening.

And not only is that dizzy spell linked to the end of communism, it also has a lot to do with the growing certainty about the deadly nature of capitalism.

The Spanish archaeologist Eudald Carbonell has no doubt that capitalism will disappear during the twenty-first century, not

through revolution but through a process of "thermal death." He makes this claim in his memoirs, which are titled suggestively: *El arqueólogo y el futuro* (The archaeologist and the future).

That an archaeologist should offer us these clues about the future could, in principle, be considered ironic. Among other reasons, because we are not talking here in metaphorical terms, but about the experience of someone whose job is to dig into the earth, convinced that the mysteries of our future cannot be solved through a waiting game but through an exercise in excavation. And this is because the future has not been postponed, but rather it has been hidden; we must bring it out into the open rather than waiting for it to arrive.

If the future is already here, if it's what we are already living, then we're better off digging into the different layers of the surface hiding it than continuing to think about the layers of varnish coating it.

VII

"This Revolution is not for generations to come; if this Revolution is successful, it's because it is for its contemporaries."

Do you remember this phrase from the beginning of the Revolution?

Well, fifty-five years after saying this, having reached his ninetieth birthday and the destiny he had drawn for himself, Fidel Castro ceased to exist. His death, and the subsequent mourning, underpinned that sense of mortality while plunging the country into an intense silence. Taxi drivers' ubiquitous reggaeton disappeared. The procession returning his ashes to their origin—a guerrilla invasion in reverse—silenced even the hymns. It led to the conviction that a whole era was on the move, accompanying Fidel in the funeral procession.

His death didn't just turn off the soundtrack to recent years; it also made clear that the historic generation of the Revolution was coming to an end. In case there was any doubt about this, Fidel's successor had already cleared things up, emphasizing that in 2018 he would step down from the presidency (although everything suggests he will remain at the head of the Party, hypothetically, until 2021).

So in 2017 Raúl Castro's last year at the head of the Cuban government coincides with Donald Trump's first year at the head of the United States government. So the children and grandchildren of those contemporaries who made the Revolution happen—or those for whom it was carried out—will have to take over the country's reins.

The time has come when the New Man envisaged by Che Guevara—that collective Frankenstein shaped by those who did not know Batista's Old Regime—will have to reset his watch, assume his own political contemporaneity, and find a balance between his power and the era he is living in for the first time.

Various analysts had predicted that, in the event of Fidel Castro's death, there would be a popular uprising calling for democracy. They envisaged a US naval blockade to prevent a mass exodus to Miami. They predicted the dismantling of the State's repressive political apparatus. They visualized the definitive collapse of the system. ("No Castro, No Problem.")

But none of this happened. Perhaps, after so much fiddling with the future, Cubans have lost respect for futurology. This final epigraph tries to guess what is to come, so it is no stranger to such boldness, nor such indifference.

If you wanted to understand Cuba, you've come to the right place . . .

And now, just when the post-revolution is about to come into contact with post-democracy, it's highly likely the presidency will

go to someone born during the Revolution. We know that person will be part of the state and Communist Party apparatus. It's unthinkable, however, that they could wield the same enormous amount of absolute power as Fidel or Raúl Castro did (they might even just be a façade for the real power of the army). And they will inevitably forge ahead with the changes begun by Raúl, because any attempt to reverse them would be even more disastrous.

Given the disadvantages of having potential—which in Cuba amounts to a cry of "off with their heads!"—Vice President Miguel Díaz-Canel (born in 1960 in Placetas, an old province of Las Villas) has a decent chance of becoming that figurehead of Castroist post-Castroism.

Whoever the next leader, they will not be able to rely on cap-ital-*H* History, nor will they be accompanied by a mythical aura; rather, they will have a biography very similar to the rest of their fellow citizens. They will have received scholarships and been to "escuelas al campo" to learn about agriculture; they will have admired Cuban socialism's sporting heroes and watched tele-vision series that glorified State Security agents. They will have a family splintered across the diaspora as well as on the island. They will have fought in Nicaragua, Angola, or another hot war in Africa during the Cold War. They will have listened to nueva trova and heeded the call of voluntary work. They will have sworn fidelity to socialism and joined the chorus shouting "Seremos como el Che!" (We will be like Che!). They will know latrines, pro-miscuity, solidarity, the cruelty of overcrowding. They will know collectivization and shamelessness as ways of experiencing desire under Cuban socialism, where the spirit of the law is distant or nonexistent. And they will come from Absolute Truth to assume command of a country in what is known as the "post-truth" era.

The next government will inherit reform before the Revolu-tion, Raúl before Fidel, globalization before the Cold War. They

will have the advantageous Cuban Adjustment Act in their sights more than the disadvantageous embargo. They will therefore have to channel discontent with fewer available escape valves (Cuban emigrants will see their US privileges disappear, and Cuba's normalization in a global context will involve sharing not only in everyone else's justice but also in their injustices). Domestically, communist activists—an increasingly decimated troop—will not be enough, and even if a multiparty system does not feature in their plans, they will still be forced to incorporate a broader political diversity.

This New Man in power will have to exchange a perfect future for a possible future. And he will have to accept that socialism and capitalism are no longer, by any stretch of the imagination, what the Revolution or its opponents promised in their moments of glory.

THE TRUMP-THUMP
2016

Donald Trump has become the forty-fifth president of the United States. This didn't happen out of nowhere—rather, it was nothing if not anticipated—and he didn't defeat just Hillary Clinton in the election. Along the way, he also defeated his own party, Hollywood, the media, outdated progressivism that speaks for a people it barely knows, the polls, democracy's organic intellectuals, the world (forever expecting global leadership from the United States), multiculturalism, gender politics, immigrants, welfare, and even language: in particular, politically correct language, which he has taken it upon himself to lay into mercilessly and with total impunity.

The list of those who have lost is undoubtedly long, but not so long as to hide the inevitable question: Who has *won*, then, with Trump in power? Well, apart from Trump himself and his acolytes, of course, his victory reveals the bared teeth of the raging masses, their rebellion channeled into votes. Votes with a *V* for vengeance.

Trump's victory is a victory of the garish and gaudy over the gently gleaming. So, the more stars there were in Hollywood, the more intellectuals, the more serious progressives determined to defenestrate him, the more these things fueled the furious vote of a proletariat who, faced with a choice between hypothetical emancipation and certain exploitation, has opted for the latter.

We live in a world where journalism has more media outlets than ever before. It is also a world where each of those media out-

lets takes an increasingly unanimous stance. So it is no surprise that a silent majority, camping like the barbarians on the outskirts of that immaculate perimeter, should come out in favor of Trump. A human conglomerate whose means of communication consists, that's right, of a vote that cannot be guessed.

With Trump's ascendence, US exceptionalism has made a comeback, as has its recurring protectionism, underpinned this time by a leader who would rather keep Utah than Brussels happy. And he is not alone in the world, by the way; he has no shortage of like-minded thinkers in Europe willing to cheer him on. We can already see the red carpet being rolled out by Le Pen in France, Wilders in Holland, Farage in England, Orbán in Hungary and—with the caution required by his position—perhaps even Putin in Russia. At the end of the day, Trump is the first leader of such geopolitical magnitude who has turned out to be as unexpected and informal as global terrorism. Moreover, the US election result, combined with Brexit, has created a disturbing remake of the eighties Reagan-Thatcher tandem, as well as a reminder that the United States and the United Kingdom, from their isolated distance, can dominate the world.

But Trump also represents the triumph—perhaps definitive—of post-democracy. The mortal blow to a liberal tradition that has been jettisoning freedoms in the name of the economy, and human rights in the name of security. (A black musician was saying yesterday that this is the first US president to have the support of the FBI, the KGB, and the KKK.)

He is not the first US president to believe he is above politics. (Reagan already did that, albeit propped up by a think tank that gave ideological cover to his conservative revolution.) But Trump has arranged things such that he can drag with him—with no theory in sight—a large part of the masses, the multitude, the people, the crowd, the population, the citizenry, the civil society,

who gave Gramsci, Ortega y Gasset, Canetti, Negri, and Badiou such a headache and who continue to provoke so many semantic debates among a left wing that cannot figure out its place.

If Lenin proposed to channel discontent by creating a revolutionary situation, Trump has channeled it by creating a reactionary situation.

This is the hangover we'll have to nurse, the trump-thump from which we'll have to pick ourselves up, assuming there is enough aspirin—or a standing eight count—for us to do so.

INTERRUPTION:
Two Futures That Happened While You Were Busy Thinking
2019–?

These final pages are a sign that we have survived those two futures against which this book positioned itself in its opening pages. The remnants of that disproportionate time ahead that always ends up vanishing while we are busy thinking about it.

They are also a platform from which to confront another paradox: that "badly distributed" future that was waiting to step in, and which is already here, doesn't seem so new after all.

There is evidently no shortage of new blood, though.

These new recruits, as Marx foresaw, will resemble the times more than they do their parents. And these times that are already reflecting their image back at them are characterized by a total crisis of traditional political models, including the model of Cuban socialism and several of its rivals, which are dragging six decades of experiments and permanent standoffs behind them.

This alarm has already sounded here, but the warning is worth repeating. The collapse of communism has dragged the liberal order and even democracy—defeated by now by the market—down with it.

So what version of socialism, of democracy, of capitalism can be proposed on the island today? In what ratios will these doses of the future be mixed? And what fate will such equations have in store for Cuba? A liberal republic as liberalism is in its death throes? A post-communist country in the grip of shock therapy? A West Indian emirate with different laws for natives and for for-

eigners, workers and investors, the powerful and the masses? An offshoot of the Chinese model? Will it find a balance that manages, finally, to mix socialism and democracy and launch another Cuban way? A State of Permanent Conjunction?

For now, what's on the table is a mixture of a one-party system with a private economy, a certain envy among officials for the Vietnamese model, and a generation of millennials for whom messianism as a political style and sacrifice as a vehicle for future redemption do not work.

In 1960, a year before Fidel Castro gave a well-worn speech to intellectuals, Sartre met with largely the same group, in the same place: the National Library. There he delivered some phrases that would go down in history, and which he would later collect in his book *Ouragan sur le sucre* (Storm over sugarcane), which closely examines the Revolution's generational situation.

"Given that a revolution was necessary, circumstances dictated that youth should carry it out. Only youth had experienced sufficient anger and angst to undertake it, and had sufficient purity to carry it out."

Today's Cuba is presumably not obliged to have another revolution. But new generations *are* obliged to set their watches, channel their rage, and become the contemporary politicians of their own project.

Fidel Castro was always obsessed with history. How could we forget *La historia me absolverá* (*History Will Absolve Me*), his first political project and also his first great slogan?

But the inhabitants of Cuba's futures will be the proof that Fidel Castro, to put it simply, is to be continued by history.

"To be continued," in fact, is a good phrase with which to close this book.

THE ESSAYS AND THEIR CIRCUMSTANCES

The essays and their circumstances. Partly their facilitators, partly their owners. Because, although the book jacket might say otherwise, the copyright does not always belong to the author. And in the end, I am no more than a chapter in these essays and the circumstances that prop them up or derail them, sink them or keep them afloat.

"Between the Devil and the Deep Blue Sea" was first published as "Más acá del Bien y del Mal" in Plural, 1991; and in *Mythos & Gesellschaft*, a Goethe Institute publication, 1991.

"One, Two, Three, Ensayando..." was first published as "Un, dos, tres, ensayando..." on my blog, December 2010, and republished in *El Estado Mental*, January 2016.

"Toward a Comparative Counterculture," originally "Por una contracultura comparada," contains elements of a text written for the catalog *Playgrounds: Reinventar la plaza* for the Reina Sofía Museum, and it includes arguments from "El cóndor pasa," an essay-manifesto, published in 1989, and from "Del Yo al Nosotros," published in 1996. It was hard to leave these last two pieces out of the book, but they created more reiteration than was necessary.

"The Year We Brought Down the Wall" is a version of "De la utopía a la intemperie," which appears in my anthology *Paisajes después del Muro*, Península, 1999.

The arguments in "The New Man in Berlin" appear in my book *Fantasía roja*, published by Debate, 2006. It also picks up ideas from the introduction to the anthology titled *Cuba y el día después*, published by Mondadori, 2001.

"Caliban's Banishment," originally "El destierro de Calibán," was written for the group exhibition *Memoria de un viaje*, commissioned by Manuel García,

1996. The magazine *Encuentro de la Cultura Cubana* published a more essay-like version, which is the one that appears in this book.

"Miami, After Christo" embodies the spirit of several articles dedicated to that city and written for *Ajoblanco*, *Lápiz*, *Lateral*, and *La Vanguardia* in the nineties.

"Nightmares in Miami" forms part of an homage to this group of creative practitioners that I organized for the magazine *Encuentro de la Cultura Cubana*, 1998.

"Traces of a Body Out in the Open" organizes the notes from a lecture given at the Universitat de les Illes Balears, Palma de Mallorca, September 1998.

"The Revolution Will No Longer Be for Bipeds" was first published as "La revolución ya no será para bípedos" in *El Estado Mental*, 2016.

"Democrat, Post-Communist, and Left Wing" was first published as "Demócrata, poscomunista y de izquierdas" in *Encuentro de la Cultura Cubana*, 2002.

"Cuba as Collateral Effect" was first published as "Cuba como efecto colateral" in *El País*, April 3, 2003.

"Nietzsche's Cuban Gloves" was first published as "Los guantes cubanos de Nietzsche" in *Babelia*, June 2004.

"Spielberg in Havana: A Minority Report" was first published in *Der Tagesspiegel* in 2003. *La Vanguardia* published a version with the title "Ni Guerra Fría ni muerte."

The first version of "Turning Rhapsody into Rap" was published in 2004 in *La Vanguardia* as "Rapsodia en rojo." A much longer version, closer to the one included in this volume, was published as a prologue to *Fantasía roja*.

"The Long Brand" gathers several texts published in *Fantasía roja* and *El País*.

"A Sequel to '68" is a version of an essay written for the Stan Douglas retrospective: Past Imperfect. The exhibition took place in Kunstverein, Stuttgart, 2004. Another version appeared on the blog *Penúltimos Días*.

"The Morenos' Song" is a revision of a chapter titled "El canto de los morenos" in *Fantasía roja*.

"El Negro Iván and Big Data" was first published as "El negro Iván y el Big Data" in elDiario.es, February 16, 2015.

"Guantánamo and Its Metaphors" was first published as "Guantánamo y sus inútiles metáforas" in *El País* between one promise made by Obama and another by Arte Contemporáneo, the first broken, the second kept, for us to suffer its consequences.

"Soccer or Baseball?" was first published as "¿Fútbol o béisbol?" in *Jot Down Magazine*, 2012.

"Generation '?'," originally "Generación '?'," is one of the articles in *La semana en una imagen*, a weekly column written during 2011 for *Diario de Cuba*.

"Back to the Present" was first published as "Regreso al presente" by *El Periódico de Catalunya*, 2008.

"Back to Batista" first appeared in *El País*, May 5, 2012.

"The Moon Walkers" was first published as "Los caminantes de la luna" on the blog *Tormenta de ideas*, *El País*, 2012.

"El Loquito as I Imagine Him" is an evocation of the character created by my father for the weekly publication *Zig Zag* in the fifties. It was published as "El Loquito, tal como yo lo conocí" in *La Gaceta de Cuba*, 2007, as part of an homage on the fiftieth anniversary of the character's debut in Cuban comics.

"The Impending Blow" was first published as "El martillazo pendiente" in *Babelia*, November 2014, in an issue dedicated to the twenty-fifth anniversary of the fall of the Berlin Wall.

"Apotheosis Now" was first published as "Apoteosis Now" in *El País*, March 2015. An English version later appeared in *e-flux*, translated by Ernesto A. Suárez.

"Iconocracy" was first published as "La imagen lo absorbe" in *El País*, November 26, 2016, on the day Fidel Castro died. It was actually written a few years earlier, in response to one of his many deaths that did not in fact occur.

"The Banquet of Consequences" is a version of "El capital cubano," a text written for a Harper anthology. It collects ideas from articles written for *elDiario.es* and *La Maleta de Portbou* in 2016–2017, and from the essay "Mañana fue otro día," published in the catalog *Adiós Utopía*.

"The Trump-Thump" was first published as "La trumpada" in *El Estornudo*, November 14, 2016. Its arguments are based on an interview I did with Cuban journalist Abraham Jiménez Enoa for Al Jazeera about who would win the elections in the United States.